Theatre in Passing 2

Theatre in Passing 2:
Searching for New Amsterdam

by Elena Siemens

intellect Bristol, UK / Chicago, USA

First published in the UK in 2015 by
Intellect, The Mill, Parnall Road, Fishponds, Bristol, BS16 3JG, UK

First published in the USA in 2015 by
Intellect, The University of Chicago Press, 1427 E. 60th Street,
Chicago, IL 60637, USA

A catalogue record for this book is available from the
British Library.

Cover designer: Holly Rose
Copy editor: MPS Technologies
Production Manager: Tim Elameer
Typesetting: John Teehan

ISBN 978-1-84150-743-9
ePDF ISBN 978-1-78320-386-4
ePUB ISBN 978-1-78320-387-1

Printed by Print On Demand, UK

Contents

THEATRE IN PASSING 2

Searching for New Amsterdam

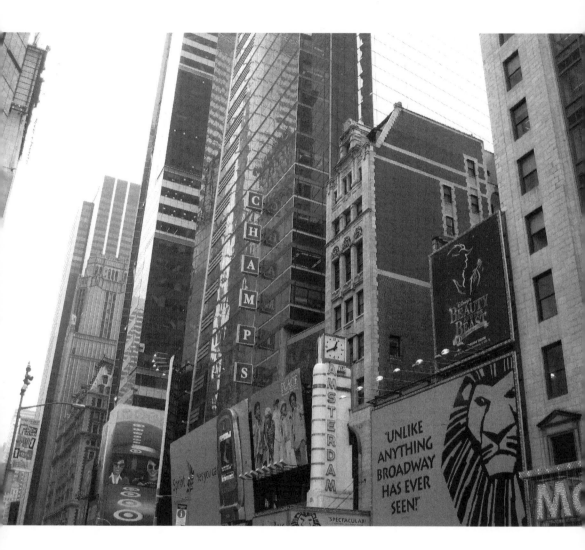

Times Square with a partial view of the New Amsterdam Theatre.

Café Uncle Vanya Manhattan

New York City, 2006. I came to Broadway in search of the New Amsterdam Theatre that served as the setting of *Vanya on 42nd Street* (1994), a cinematic adaptation of Anton Chekhov's play *Uncle Vanya* (1897). Directed by the innovative team of Louis Malle and Andre Gregory, the film was shot in the then-abandoned New Amsterdam, with the actors performing in street clothes. The original *Uncle Vanya* takes place at a provincial country estate in pre-revolutionary Russia. Seeing it staged in the contemporary setting of a rundown Manhattan theatre was a complete surprise and it left a lasting impression on me.

Looking for the New Amsterdam, I at once ruled out the glittering Times Square, and instead went to a quiet side street lined with old-fashioned venues resembling more closely the film's understated milieu. I was used to calling it "Vanya", and did not remember the rest of the title, which contained crucial information about the address. Isolated passers-by were understandably at a loss when I asked about an esoteric Chekhov film from the 1990s and the venue in which it was shot. Months later, sorting out my photographs, I came across a cluttered picture of Times Square, featuring a fragmented view of the New Amsterdam, its façade decorated with prominent billboards for *The Lion King* (1994). Looking for some explanation of this metamorphosis, I learned that, soon after the film had been completed, the theatre was leased to The Walt Disney Company and restored to its original 1903 splendour, when it was home to the legendary Ziegfeld Follies.

On my next trip to New York, I photographed Central Park with its Delacorte Theatre, and Café Uncle Vanya, which I discovered by accident in Midtown. I considered my search for the New Amsterdam to be more or less complete. The outcome was not exactly what I had hoped for, but not finding the old New Amsterdam was also a blessing. In my memory this theatre will always remain the setting of *Uncle Vanya*, and a small slice of Russia in the middle of Manhattan.

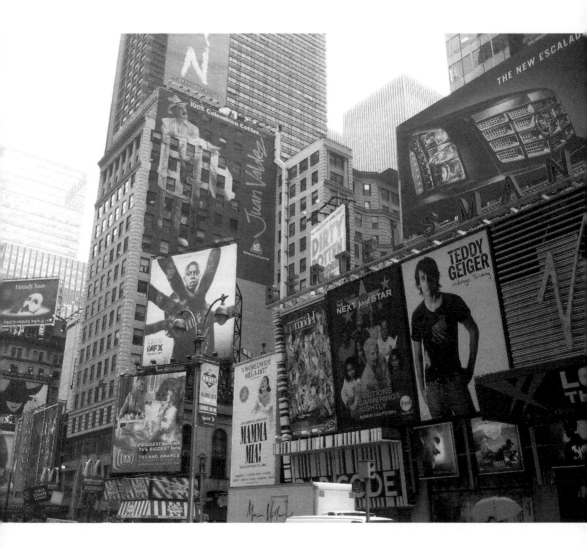

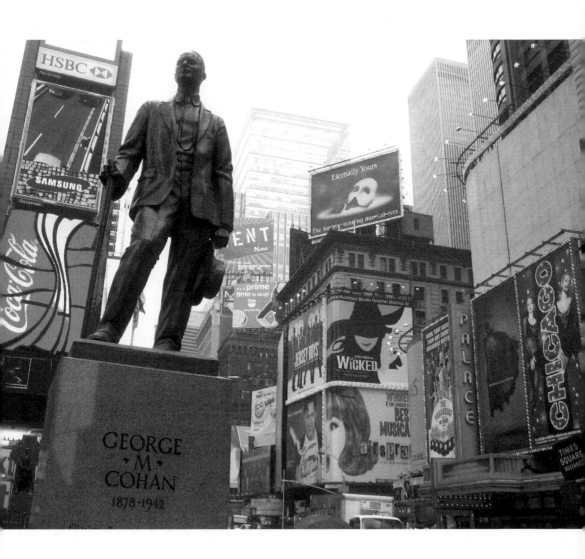

The statue of George M. Cohan appears inconsequential against Times Square's giant billboards. As with the Pushkin statue in Moscow, also dwarfed by its surroundings, I photographed Cohan from the "bottom up," an avant-garde perspective advocated by the famous Rodchenko.

Old-fashioned theatres on West 45th Street. Except for the ubiquitous yellow taxicabs, this quiet street, located just off Times Square, resembles the setting of a Hollywood costume drama.

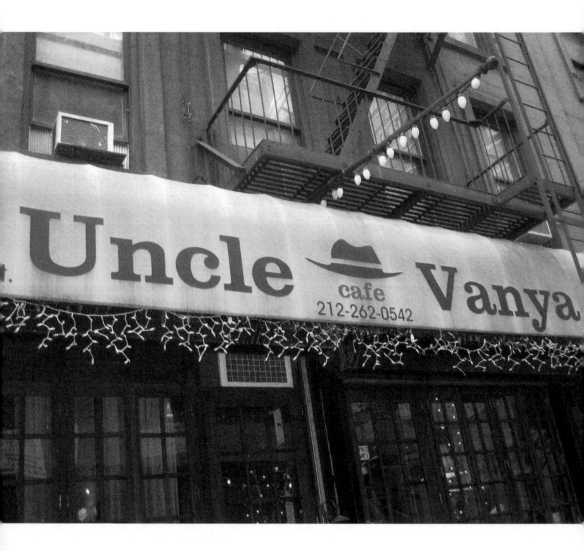

Café Uncle Vanya, West 54th Street Manhattan.

In Act Four of Chekhov's play, Uncle Vanya (Ivan Petrovich Voynitsky) still hopes to start over. He appeals to Doctor Astrov:

VOYNITSKY: [...]. I'm forty-seven years old. Let's say I live to be sixty, that leaves me thirteen more years. That's a long time. How can I get through those thirteen years? What will I do? What can I fill them up with? Oh, you can understand ... [*Fervently squeezes ASTROV's arm*] you can understand what it would mean to live the rest of your life in some new way. If you could wake up one clear, quiet morning and feel that you're beginning your life over again, that the entire past is forgotten, scattered to the winds like smoke. [Weeps] To begin a new life ... Give me a hint, tell me how to begin ... what to begin with ...

ASTROV: [*with annoyance*] Oh, come on, now! What do you mean, a new life! Our situation, yours and mine, is hopeless.

VOYNITSKY: Yes?

ASTROV: I'm sure of it.

VOYNITSKY: Then give me something at least ... [*Points to his heart*] I'm burning up here.

ASTROV: [*shouts angrily*] Stop it! [*Mollified*] Those who come after us, in the course of a hundred or two hundred years, and who will despise us for making our lives so stupid and so tasteless, perhaps they will find ways to be happy, but as for us... [...].

(Chekhov 1977: 90)

Street Signs Paris

Walking in Moscow and taking pictures of its theatres for my previous book, *Theatre in Passing: A Moscow Photo-Diary* (2011), was relatively easy. Although I now live and work in Canada, I still feel at home in Moscow. I see myself as a "walker" there, and not a "voyeur." According to Michel de Certeau's *The Practice of Everyday Life* (1988), the voyeur observes the city from some elevated perspective, such as the top of the Eiffel Tower, from which the terrain below unfolds like a map. By contrast, walkers remain on the street, taking full advantage of shortcuts and back alleys. Walkers do not "read" the city like a map; they "write" it (De Certeau 1988: 93).

Taking pictures inevitably turns you into an observer, a close relative of the voyeur. I try to mitigate this by staying close to the ground, avoiding, whenever possible, panoramic shots. Capturing the Bolshoi Theatre, I followed the example of Alexander Rodchenko, a prominent avant-garde photographer, who insists that well-known landmarks must be shot from unusual points of view so as to defamiliarize their habitual perception. Rodchenko himself excluded the Bolshoi altogether from his 1930s photograph of Theatre Square. Instead, he took his picture from the roof of the landmark theatre.

My new project, focusing on spaces of performance beyond Moscow, forced some significant changes to my approach. Navigating an unfamiliar territory, I was no longer a "walker," who travels at will and subverts the city's "official geography." I now had to rely on street signs, maps, and tourist guides. My international cast of friends, as well as the occasional passers-by, also served as an invaluable source of information. Frequent challenges of geography and foreign culture notwithstanding, I still avoided climbing towers in search of all-encompassing views, continuing instead my usual practice of staying close to the ground and observing the world from the sidewalk.

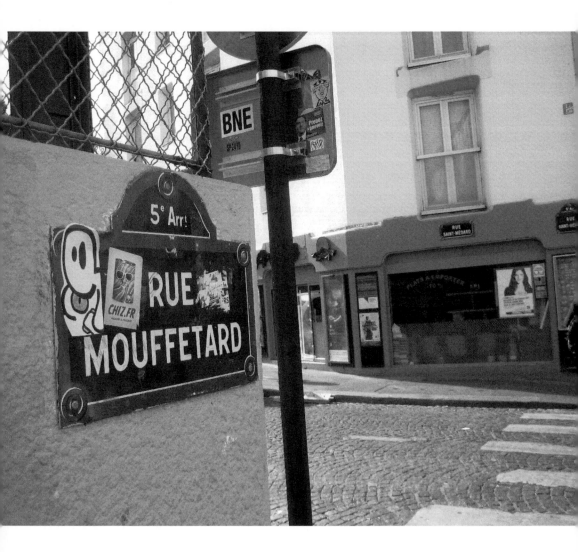

It took some time to find the elusive rue Mouffetard, and I was grateful for the large street sign announcing its presence. I went to rue Mouffetard on the advice of Gordana Zivkovic, an artist and my university colleague from the Department of Fine Arts. According to Gordana's enthusiastic account, rue Mouffetard contained many attractions, including some small theatres. I had mostly photographed Paris's more prominent theatrical landmarks, such as Opéra Garnier and Comédie Française, and was looking forward to discovering something less well-known. Distinguishing between the public and secret spaces, De Certeau argues that "the city is left prey to contradictory movements that counterbalance and combine themselves outside the rich of panoptic power" (De Certeau 1988: 96). I was eager to witness first-hand those "ruses" that lie beneath "the discourses that idealize the city" (De Certeau 1988: 95). Looking for the promised theatres, I walked the entire length of rue Mouffetard, taking occasional snapshots of store fronts and a recurrent piece of graffiti depicting a running man chased by a flock of birds. I was able to find just one theatre: the Théâtre Mouffetard. Hidden in a courtyard, this unassuming venue blends perfectly with its surroundings. Predictably, tourist guides make no mention of it. For example, *The Mini Rough Guide to Paris* (Kabbery and Brown 2011) describes rue Mouffetard as follows:

> Beginning just off tiny place de la Contrescarpe, medieval rue Mouffetard has slightly tacky tourist leanings, but nevertheless offers some authentic local ambience. It's lined with numerous clothes, shoe, secondhand record and CD shops, and unpretentious cafés. The lower half of the street is taken over by a lively market on Tuesday and Sunday mornings.

> (Kabbery and Brown 2001: 77)

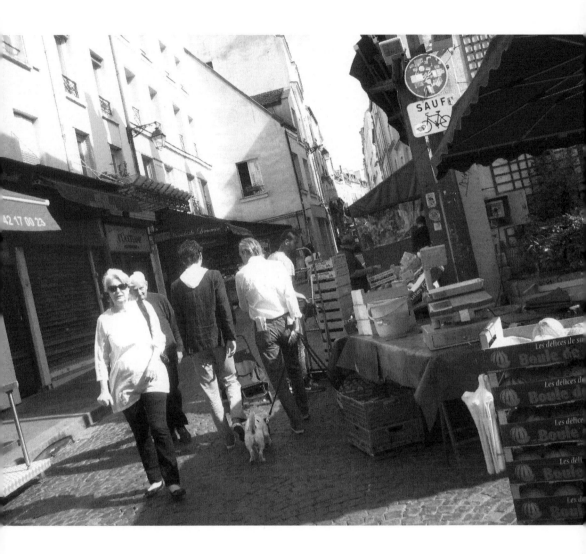

Market day on rue Mouffetard, Paris. The unassuming Théatre Mouffetard in the opposite picture blends perfectly with its surroundings.

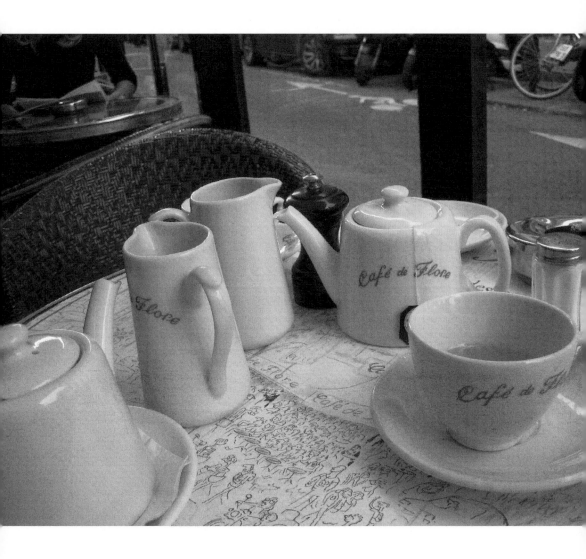

According to Marvin Carlson's *Places of Performance: The Semiotics of Theatre Architecture* (1989), which inspired my Moscow book, "almost any identifiable space within a city may become a performance space" (Carlson 1989: 36). Carlson refers to several street theatre directors of the 1960s and 1970s, among them Douglas Peterson and Armand Gatti, who utilized factories, cafés and other "specific urban elements symbolically related to their performances" (Carlson 1989: 34). At the legendary Café de Flore in Paris, the old-fashioned teapots and cups looked authentic, as if they had arrived straight from those glorious old days when Sartre and De Beauvoir still came here to discuss art, philosophy, and the plight of the post-war world. I took a few snapshots of the dishes, to commemorate the occasion, and also as a tribute to Chekhov and his frequent references to tea-drinking. The first act of *Uncle Vanya* takes place in a garden. The stage directions read: "Part of the garden and the veranda are visible. A table set for tea has been placed in the pathway under an old poplar tree" (Chekhov 1977: 55). The play begins with the following exchange between the old nanny Marina and Doctor Astrov:

MARINA: [*pours a glass of tea*] Take some tea, my pet.

ASTROV: [*takes the glass reluctantly*] Somehow or other I don't feel like it.

MARINA: Maybe a drop or two of vodka?

ASTROV: No. I don't drink vodka every day. Besides, it's too muggy. [*Pause*] How many years have gone by, nyanka, that we've known each other?

(Chekhov 1977: 55)

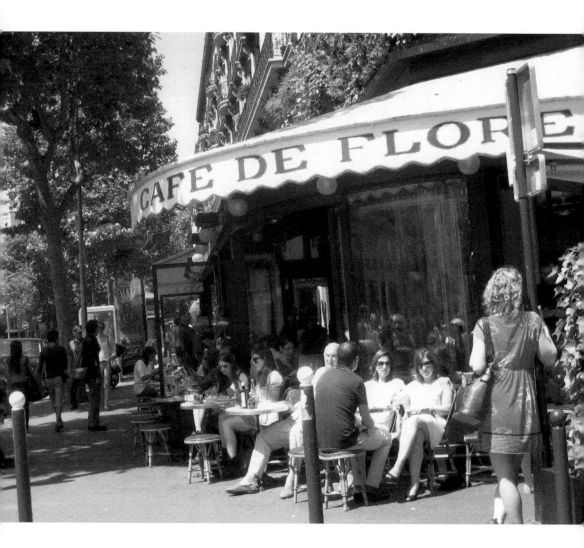

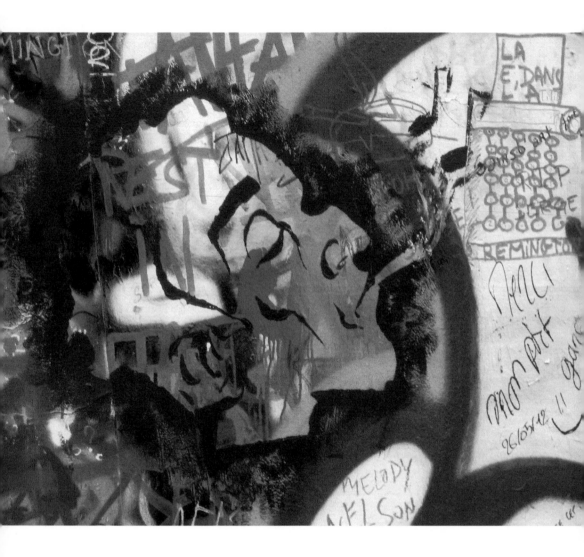

A helpful sales clerk at the Café de Flore souvenir shop explained how to find the nearby 7L Bookshop, named after its location on 7 rue de Lille. I had heard it offered an impressive selection of titles on architecture and photography, and was owned by Karl Lagerfeld himself. The friendly sales clerk also suggested I take a small detour to visit the famous singer Serge Gainsbourg's house on rue de Verneuil, decorated with remarkable tribute graffiti. Compared to the Victor Tsoi Wall in Moscow, commemorating the late lead singer of the rock group Kino (Cinema), Gainsbourg's memorial was more festive, its graffiti employing a wild selection of colour. I photographed several striking portraits of Gainsbourg, and a passage from his song written in cursive against a bright pink-and-blue background:

> *Le soleil est rare/ Et le bonheur aussi/ L'amour s'égare/ Au long de la vie …*
> (The sun is rare/ and happiness too/ love drifts away/ throughout our entire lives).

(Sutton 2012)

At the 7L Bookshop, the staff was equally friendly. Vincent, who manages the shop, identified the song and summed up its content. The song seemed to contradict the bright palette used by the anonymous graffiti artist. I later contacted my French friend Isabelle Sutton, a professional translator and a fellow vagabond, who emailed a more definitive translation. Working on this segment, I found out that Gainsbourg was a son of Russian Jewish emigrants, who came to France following the Bolshevik Revolution of 1917. His 1971 album *Histoire de Melody Nelson* (Melody Nelson's Story), which includes the song "La Valse de Melody" (Melody's Waltz) from my photograph, tells a story reminiscent of Vladimir Nabokov's novel *Lolita* (1955) – another Russian connection, and one more lucky find produced by that little detour.

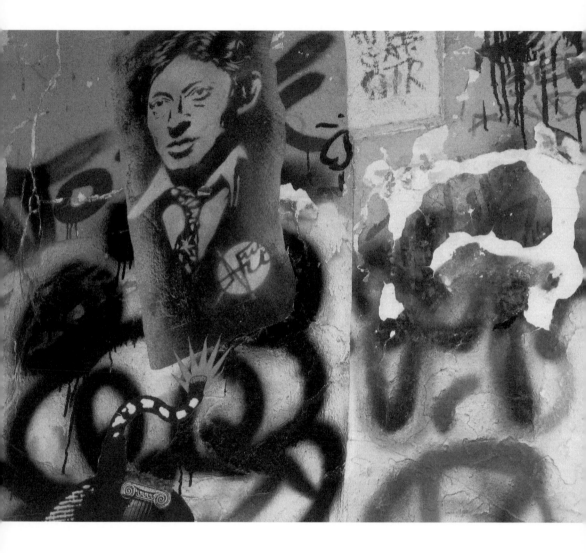

Graffiti "is first an act of performance before it is one of drawing or painting (or spraying)," Nicolas Whybrow writes in *Art and the City* (Whybrow 2011: 113). Graffiti's "true potency," he explains, "resides not only in its seeking out of high-risk, forbidden

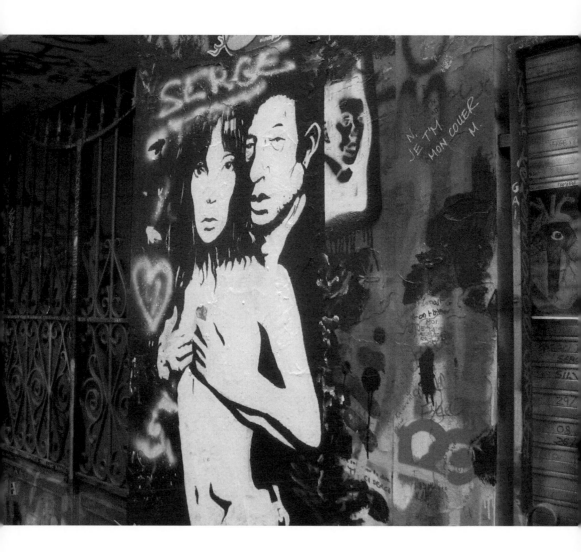

places in the city but high-visibility ones, too" (Whybrow 2011: 113). Keith Haring, who began with chalk drawing in New York's subway, has stated: "My drawings do not try to imitate life, they try to create life, to invent life" (Haring, cited in Adriani 2001: 145).

Eisenstein's Lucky Finds

Lucky finds, the director Sergei Eisenstein insists, are essential for producing a successful work of art. The famous Odessa Steps sequence from his iconic film *The Battleship Potemkin* (1925), Eisenstein reveals, was "born out of a momentary spontaneous encounter" (Eisenstein 1995: 173). He writes that the idea for this sequence came to him at the moment when he first saw the actual staircase, and that a story about him contemplating this scene while "spitting cherry-stones and watching them bounce down the steps" was pure fiction (Eisenstein 1995: 173).

"Chance," Eisenstein argues, "brings a sharper, more powerful resolution" than any "preliminary outline" (Eisenstein 1995: 172). He vehemently opposed a linear progression in film, advocating instead the "collision montage" – a compilation of unrelated images designed to agitate or shock the viewer. At the Proletkult Theatre, where he first tested this strategy, Eisenstein's productions, Marc Slonim writes, combined elements of "circus, music hall, and Grand Guignol, the Parisian theatre of horrors and suspense" (Slonim 1962: 255). In one show, a radical reinterpretation of a classic Alexander Ostrovsky play, the stage "represented an arena, and dialogues were going on while the actors tried to keep equilibrium walking on a tight rope" (Slonim 1962: 255). *The Mexican*, based on a short story by Jack London, included a "boxing match between capitalism and socialism" (Slonim 1962: 254). A theatrical production, Eisenstein declares, must be:

> a free montage, with arbitrarily chosen independent (of both the PARTICULAR composition and any thematic connection with the actors) effects (attractions) but with the precise aim of a specific final thematic effect – montage of attractions.

> (Eisenstein 1988: 88, original emphasis)

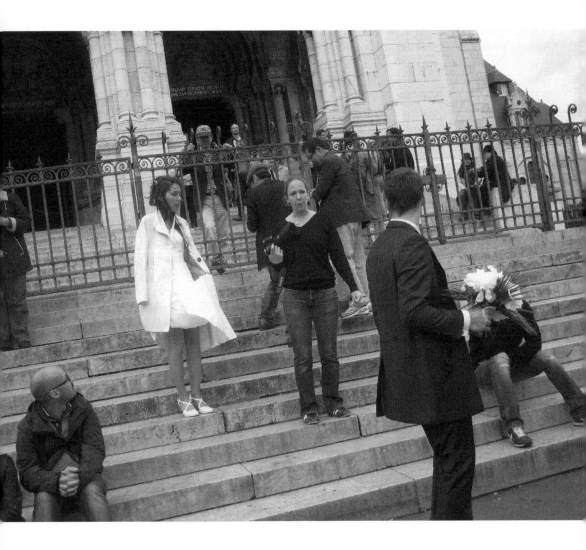

A wedding party on the steps of the Sacré-Coeur cathedral, Paris.

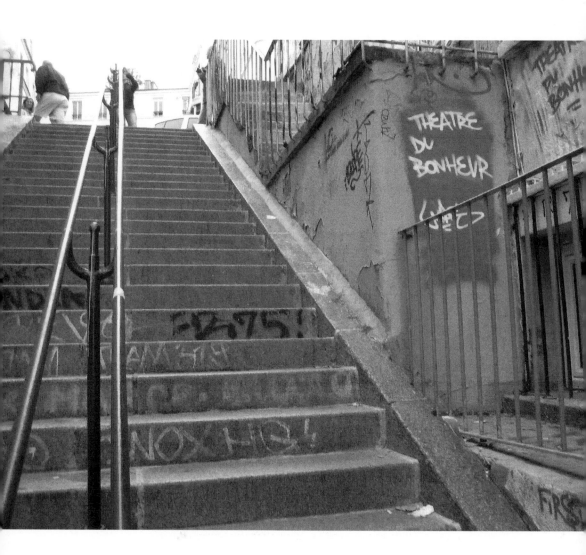

Graffiti inscriptions referring to the Theatre du Bonheur on one of the steep staircases leading to the Sacré Coeur cathedral.

In later years, Eisenstein continued to maintain strong ties with live theatre. On the day *The Battleship Potemkin* went into general release, the film's cast greeted spectators from the deck of a large replica of the legendary battleship installed near the building of the Khudozhesveny (Art) Cinema on Arbat Square in Moscow, where the film played. *The Battleship Potemkin* also received a special screening at the Bolshoi Theatre, coinciding with the anniversary of the 1905 Revolution. Eisenstein worried the entire evening. In "A Miracle at the Bolshoi," he writes: "I worried not only for the film's sake, but because of the spit. The last part of the film was held together by spit" (Eisenstein 1995: 181). He explains:

> In the rush in the editing suite we had omitted to glue the end of the last part of the film together. The splices at the end – the encounter with the squadron – were minutes. To stop them from flying apart and being mixed up, I had stuck them together with spit. [...]. The spit had not been replaced by acetone.

> (Eisenstein 1995: 181–82)

To Eisenstein's great relief, the "spit held" (Eisenstein 1995: 182). He writes that they later separated without any effort "those minute pieces that earlier had adhered to each other with miraculous strength as they sped through the projector! ..." (Eisenstein 1995: 182). His story of that remarkable night at the Bolshoi reads as yet another tribute to lucky finds and happy coincidences.

Montage of Attractions Milan

Milan, where I attended the *Fashion Tales 2012* conference, produced many lucky finds. The conference addressed some fascinating subjects from David Bowie's album covers to the fashion politics in Brazil. My new friend Maria Leon from the Madrid University of Fine Arts spoke about clothing as both art and protection, as exemplified in the work of the Czech artist and photographer Miroslav Tichy. For her talk, Maria wore a self-made red safety vest. My own contribution entitled "Museum to Factory: Clothing the Worker from Tatlin to Now" focused on early Russian avant-garde clothing design. As a tribute to Vladimir Tatlin, the creator of the famous leaning *Monument to the IIIrd International* (1919–20), I wore a functional grey flannel suit jacket. While "visually unremarkable," Christina Kiaer points out, Tatlin's "material objects, characterized by utilitarian qualities such as hygiene and warmth, represent the socialist 'new everyday life' (novyi byt)" (Kiaer 2008: 148).

The conference's tight schedule left limited time to visit several important theatrical spaces on my list. The renowned La Scala opera house, centrally located near the giant Duomo cathedral, was easy to find. Like the Bolshoi Theatre in Moscow, La Scala has an attractive garden in front of it, decorated with the sumptuous statue of Leonardo da Vinci. I was sorry to see this celebrated theatre sharing space with so many imposing landmarks. Moreover, La Scala is surrounded by busy traffic lanes, also contributing to the clutter. Moscow's Theatre Square became traffic free in the 1930s, as testified by Rodchenko's unusual 1932 photograph shot from the Bolshoi's roof. Following Rodchenko, I photographed La Scala in fragments, capturing its noble old columns, and people waiting at traffic lights near its restrained neo-classical façade.

People waiting at the traffic light near the renowned La Scala opera house. The opposite photograph depicts a fragment of the garden in front of the theatre. I left out the imposing Leonardo da Vinci statue that overshadows the more understated La Scala.

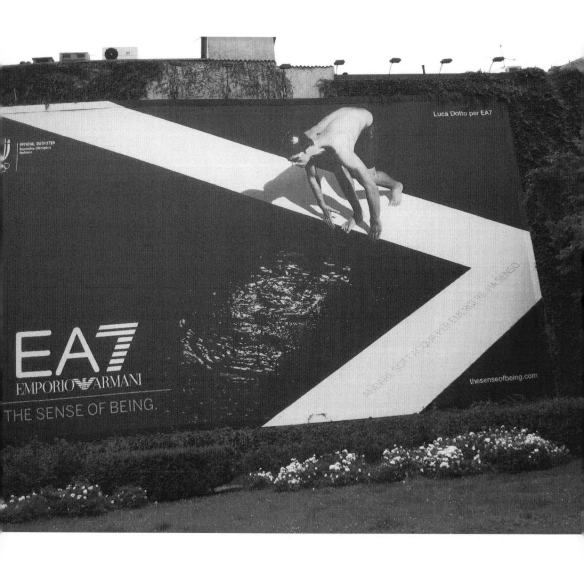

Walking to the Teatro Strehler, an inspiration behind the Meyerhold Centre in Moscow, I photographed a sleek Armani billboard. Taking up the entire wall of an old building, it transformed a vacant space in front of it into the set of some postmodernist production. Just beyond the Armani billboard was a sculpture of a giant male torso, possibly an ironic take on Michelangelo's *David*.

Further down, an advertisement of Marina Abramovic, a prominent performance artist from Serbia, was covered with a vigorous graffiti dialogue in blue and black ink. According to William Anselmi, my Italian university colleague, the graffiti represented two radically opposing views on Abramovic and her art.

Other sights contributing to the "montage of attractions" found in this part of Milan included modern office towers, old churches, the rundown Hotel Napoli, and a residential building called "Teatro Fossati." I made every effort to find some trace of the old theatre to which the building's name referred, but went away with a stack of pictures of curtained windows and wrought-iron balconies with potted flowers. Milan's trams, which I photographed on this walk and elsewhere, come in a great variety of models: the vintage ones resembling props from a production of Tennessee William's *A Street Car Named Desire* (1947).

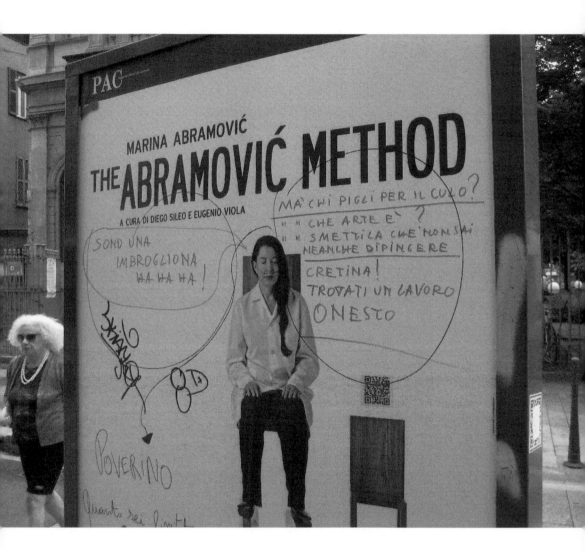

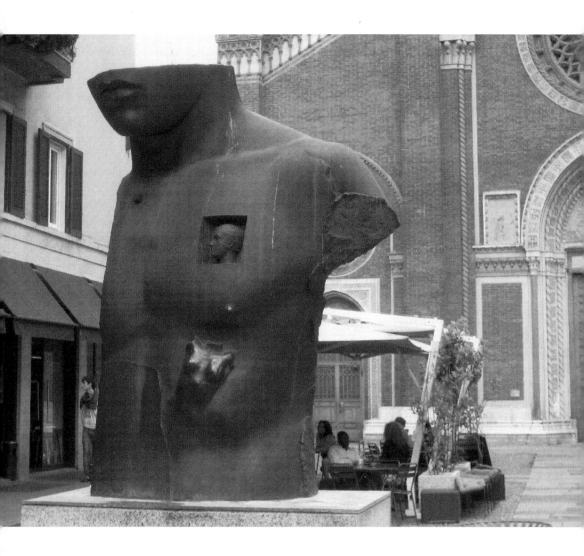

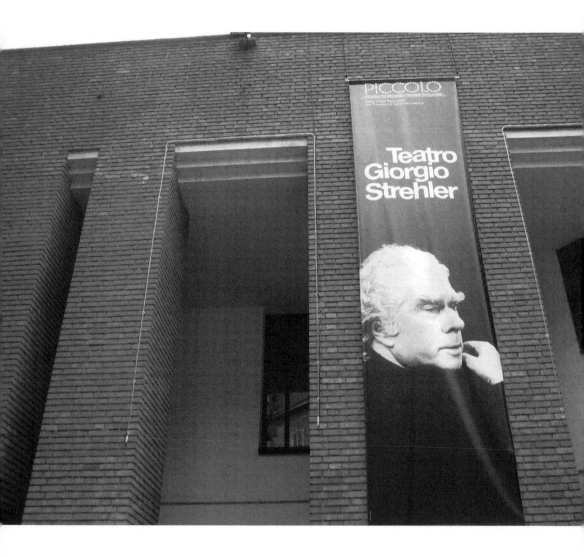

Contrary to my expectations, the Teatro Strehler did not have much in common with the Meyerhold Centre, which it had inspired. Opened in 2001, the Meyerhold Centre is a modern edifice, situated next to a Western-chain hotel, with the two buildings forming a unified architectural whole. For its part, the Teatro Strehler is located in a residential area, removed from Milan's tourist centre. Completed in 1988, this sober red-brick structure reflects the theatre's anti-establishment philosophy.

The Strehler is part of the Teatro Piccalo di Milano, Italy's first repertory theatre (*teatro stabile*), which opened in 1947 with the production of Maxim Gorky's play *The Lower Depth* (1902). The newly formed theatre described itself as "*un teatro d'arte per tutti*" (an art theatre for everyone), a slogan still used in their attractive posters, which I photographed near the old Grassi stage on via Rovello, where the Gorky play was originally performed. The Strehler itself has also staged some Russian authors, including Chekhov, whose celebrated play *The Seagull* (1898) addresses the need for a radical reconstruction of traditional theatre. In Act One, the aspiring director Konstantin Treplev states that "the theatre of today is in a rut, engrained with conventionalism," and that he wants to run from it, and "keep on running, just as Maupassant ran away from the Eiffel Tower, which choked his brains with its vulgarity" (Chekhov 1977: 8).

I photographed the Strehler's unpretentious façade, a banner with a portrait of the founder Giorgio Strehler, and the entrance of a metro station attached to the building – another evidence of this theatre's populist mandate. My departing picture of Milan also came from the metro. Riding to the Central Station to catch my return train to Paris, I took a blurry shot of the red, green and gold metro station called Moscova.

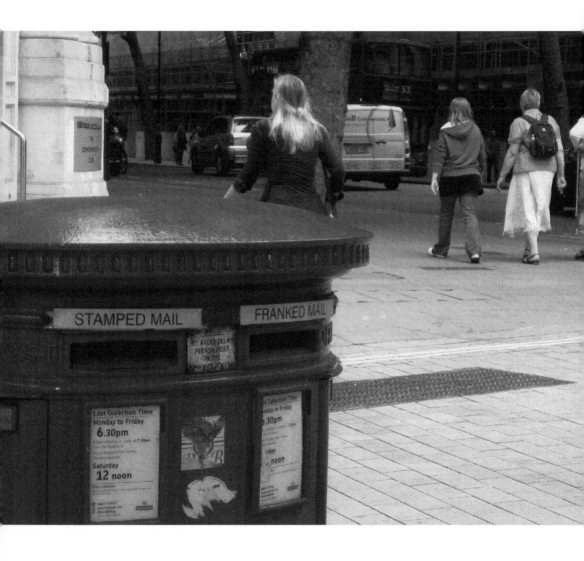

Surrogate Possessions London

My earliest set of snapshots from London: the iconic red telephone booths, red mailboxes, some theatre billboards I captured in passing, and a picture with my friend Katy Emck, who first introduced me to this city. "Photography is acquisition in several forms," Susan Sontag writes in her insightful volume *On Photography* (Sontag 1990: 155). Sontag explains that "we have in a photograph surrogate possession of a cherished person or thing, a possession which gives photographs some of the character of unique objects" (Sontag 1990: 155). In "Photography and Fetish," Christians Metz comments similarly on "the frequent use of photography for private commemorations" (Metz 2003: 141). Metz points out that unlike film, photographs cut off "a piece of space and time," and keep it "unchanged while the world around continues to change" (Metz 2003: 141).

The photograph's ability to serve as a "surrogate possession" has also fascinated Chris Marker, the director of the 1962 film classic *La Jetée* (The Pier), which is made almost entirely of still shots. Marker quotes his "school buddy," who once scorned his early efforts: "Movies are supposed to move, stupid" (Marker 2007: 176). Undismayed, Marker went on to produce his *La Jetée* 30 years later.

My first photographs of London are now a couple of decades old as well. Since then, I have taken many more pictures of this world city, where every street and street corner is a stage. Covent Garden, with its traveling minstrels, performing for crowds of shoppers. The courtyard of the Royal Academy of Arts, with its ceaseless parade of attractions from Anish Kapoor's mirrored statues to Barry Flanagan's giant bronze hares. Near the Embankment tube station, I once photographed a mime in a policeman uniform and a tutu. Digital technology makes it easy to store large volumes of pictures. I still keep a thin envelope with my first London shots. The analogue images, Chris Marker writes, are something "I could feel and touch, something of the real world" (Marker 2007: 175).

Competing venues on Shaftesbury Avenue in central London.

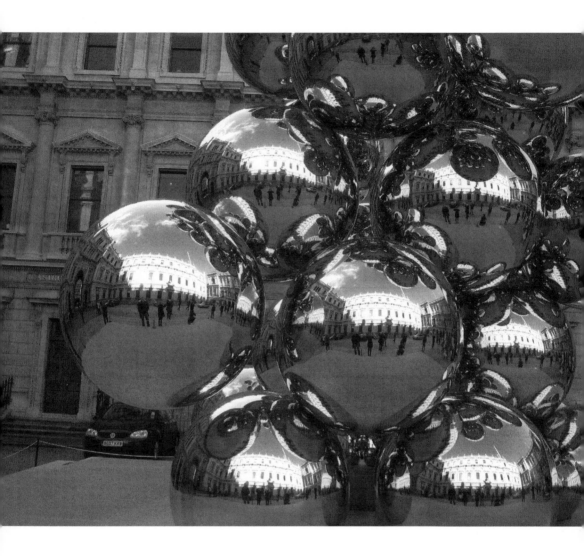

Anish Kapoor's sculpture *Tall Tree and the Eye*, exhibited in the courtyard of the Royal Academy of Arts in 2009, invited interaction with its viewers. Kapoor's works often employ "shiny industrial materials, manipulated into sumptuous curves," Charlotte Bonham-Carter and David Hodge write in *Contemporary Art: The Essential Guide to 200 Groundbreaking Artists* (Bonham-Carter and Hodge 2013: 198). Kapoor's stainless-steel *Cloud Gate* (2004) in Chicago's Millennium Park, the critics observe, "reflects and distorts Chicago's dramatic skyline" (Bonham-Carter and Hodge 2013: 198). *Cloud Gate* also "engages viewers by reflecting their own image back at them," Brad Finger and Christiane Weidemann point out in *50 Contemporary Artists You Should Know* (Finger and Weidemann 2011: 53). In London, I joined the crowd in taking pictures of myself along with other visitors as reflected and distorted in the shiny spheres of Kapoor's *Tall Tree and the Eye*.

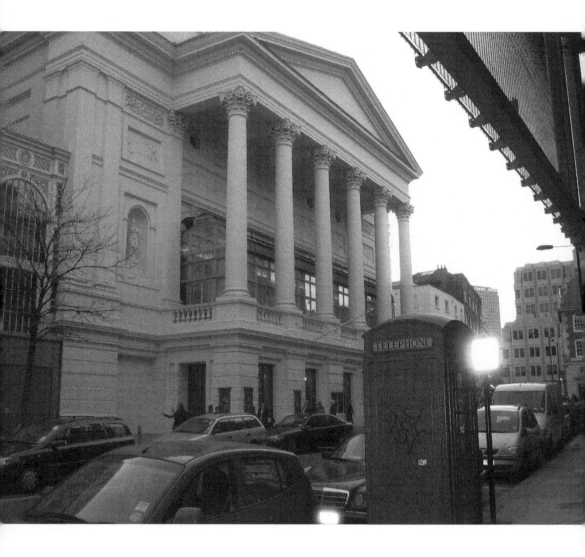

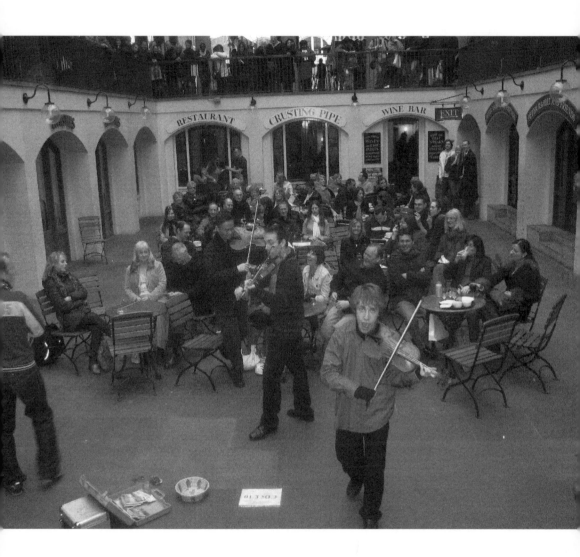

London's Covent Garden offers various attractions from street musicians to performances at the imposing Royal Opera House. With its diverse environment, this area resembles Old Arbat, Moscow's prominent pedestrian street, where the monumental Vakhtangov Theatre contrasts with numerous souvenir stands, street artists painting portraits of tourists, and Victor Tsoi's fans playing guitars and spray-painting on the decaying Tsoi Wall.

Digital Berlin

Berlin, July 2005. The entire Unter den Linden, the city's main thoroughfare, was under reconstruction. I photographed it from the steps of the Deutsche Staatsoper, Germany's most prestigious opera house dating from 1743. The theatre itself also appeared in need of serious renovation, as evidenced by my close-ups of its entrance. Giant billboards covering many buildings on and around Unter den Linden served a dual function: to advertise products and events, but also to camouflage the city's devastated look. Most of the billboards were in German, except for the Albert Einstein one. It was bilingual and read: "Albert Einstein: The Chief Engineer of the Universe."

On that trip to Berlin, I was making a transition to my first digital camera, and was going through a radical "reconstruction" of my own. In the opening of *On Photography*, Sontag refers to Jean-Luc Godard's *Les Carabiniers* (1963), in which the two protagonists return home after years of travel with a "suitcase of booty," containing, to their wives' astonishment, nothing but "picture postcards, hundreds of them," depicting various landmarks from around the globe (Sontag 1990: 3). Commenting on Godard's film, Sontag points out: "Photographed images do not seem to be statements about the world so much as pieces of it, miniatures of reality that anyone can make or acquire" (Sontag 1990: 4). I was used to returning from my trips with a similar "suitcase of booty" – rolls of film, as well as some developed photographs. The thought of coming back with virtual, rather than tangible evidence of my expeditions left me anxious and uncertain.

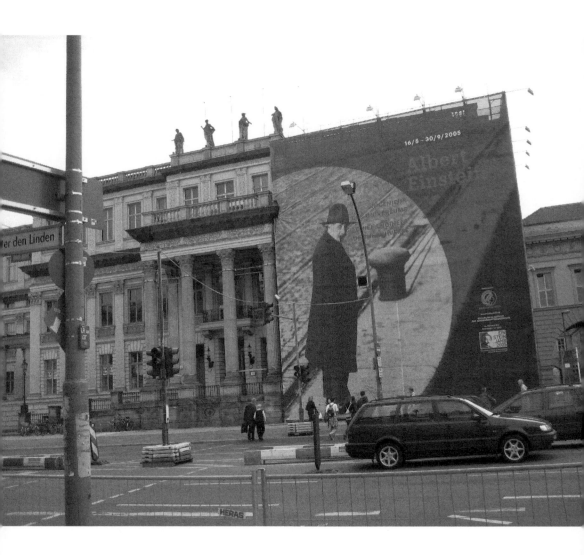

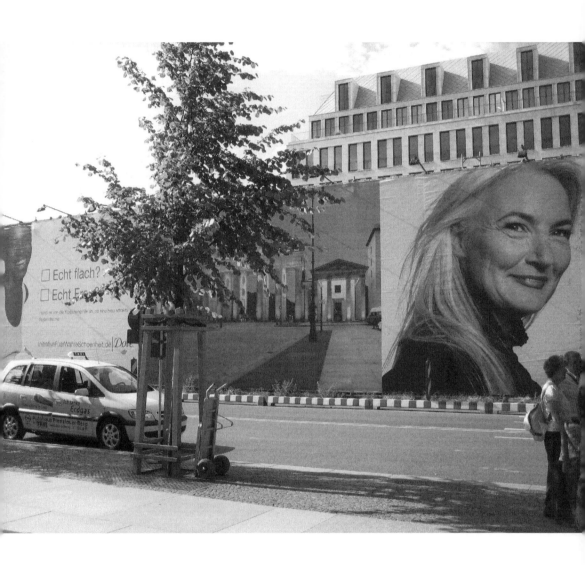

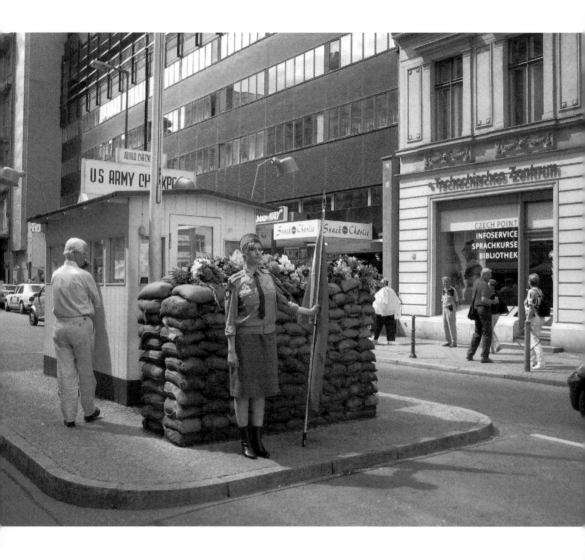

My new digital camera's advanced technology also required some getting used to. Sadly, my rather vague pictures of the Bertolt Brecht statue near the Theater am Schiffbauerdamm testify to this. Brecht has had a profound impact on Russian theatre, and in particular the rebellious Taganka Theatre in Moscow, which opened in the early 1960s with his play *The Good Person of Szechwan* (1943). Dismissing Stanislavsky, whose method dominated the Soviet-era stage, the young Taganka Theatre introduced Russian viewers to Brecht's "distancing" – an approach designed to make viewers aware of the artifice of theatre. While immensely popular with the audience, the theatre received cool treatment from the Soviet censors, who frequently banned its productions.

I was more successful with pictures of Checkpoint Charlie, formerly a border crossing between East and West Berlin, and one of the city's most enduring tourist attractions. According to the *Frommer's Portable Berlin* guide, the original guard house "was sold to a group of American investors for its souvenir value" (Porter and Prince 2004: 126). Near the contemporary replica of the old hut, the guards in the Cold War-era uniforms made the scene even more theatrical. A nearby theatre-ticket outlet called "Theaterkasse" reminded me of Moscow, where similar outlets are found throughout the city.

Another reminder of Moscow was an exhibit of Evgeny Khaldei at the History Museum on Unter den Linden. A prominent Soviet photographer, Khaldei is best known for his iconic 1945 shot of Soviet soldiers hoisting the flag of victory atop the Reichstag. Along with the usual tourist postcards, Berlin's souvenir shops sold postcards reproducing World War II photography by Khaldei and others. Walter Benjamin, a native of Berlin, observes in his essay on Moscow: "More quickly than Moscow itself, one gets to know Berlin through Moscow" (Benjamin 1986: 97). The reverse of this might be equally true: while visiting Berlin, one gets a better picture of Moscow.

Disposable Memories Helsinki

In Helsinki, I gave a conference paper on a unique 1935 road trip across the United States made by two Soviet satirical authors, Ilya Ilf and Evgeny Petrov. Rodchenko describes Ilf's travel photography as bland and mere "bookkeeping" (Rodchenko 2007: 151). Most of Ilf's pictures, he states, capture the landscape "honestly, half sky, half ground" (Rodchenko 2007: 149). He insists that a photograph must "complicate things" and employ some sophisticated "graphic methods," such as foreshortening. I defended Ilf by comparing his understated images of road signs and gas stations to Edward Hopper's iconic paintings of rural America. According to the two Russian travellers, the real America is not "New York with its skyscrapers"; instead, they argue, this country is best represented by one of Ilf's snapshots of an anonymous "intersection of two roads and a gas station against a background of wires and advertising billboards" (Ilf and Petrov 2007: 13).

In Helsinki, I photographed both the ordinary and the extraordinary: a café, a post office, the impressive Sibelius monument, and carpets drying on wooden railings by the sea. My stack of pictures from Helsinki, all taken with a disposable Kodak, also includes some shots of the spacious Finnish National Opera, opened in 1993, and the performing arts complex Finlandia Hall, a modernist landmark by the celebrated architect Alvar Aalto. The disposable camera is a true friend in a time of need, but it also imposes some restrictions. I missed having a preview screen and had to watch constantly the little window indicating the remaining number of shots – another source of anxiety. Ilf, who experienced various technical difficulties with his Leica camera, remained optimistic: "The fact that you discovered America means nothing. The important thing is that America discovers you" (Ilf and Petrov 2007: 154).

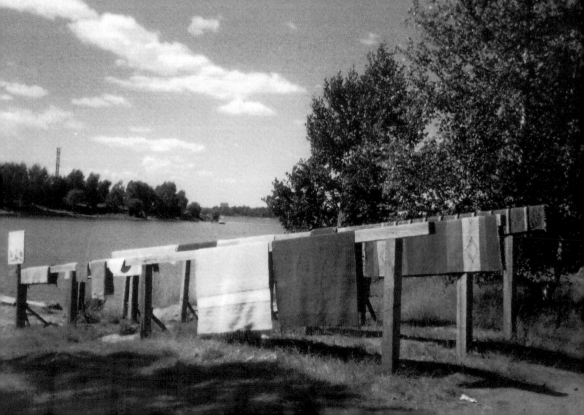

More recently, the British photographer Martin Parr has also advocated the cause of "boring" images. In *Parr by Parr*, his book-length interview with Quentin Bajac, Parr states: "the fundamental thing I'm exploring constantly is the difference between the mythology of the place and the reality of it" (Parr 2010: 57). Addressing this distinction between the mythology and the reality of a place in his native England, Parr has produced such series as *Bad Weather* (1982), *The Last Resort: Photographs of New Brighton* (1986), and *Bored Couples* (1993). In the United States, Parr meticulously documented the town of Boring in Oregon (2000). He has also travelled to Zimbabwe, United Arab Emirates, Vietnam, and Russia.

In Parr's images, Reuel Golden writes disapprovingly in *Masters of Photography*, everything "is reduced to its same basic level and we are basically what we consume" (Golden 2013: 186). According to Golden, Parr not only acknowledges but celebrates such mundane things as hamburgers, and "those tacky souvenirs and sugar-encrusted doughnuts," found everywhere from Helsinki to Moscow (Golden 2013: 186).

Explaining his approach, Parr states that part of his job as a photographer is "to find new ways of representing the world," which is why, he says, he has looked "at everything from theme parks, supermarkets, food" (Parr 2010: 65). In her more favourable account of Parr's photography, Sandra S. Phillips points to Parr's "splendid humour" – another important trait he shares with the Russian satirical authors Ilf and Petrov (Phillips 2013: 15). Phillips cites Parr's 1992 witty picture of Stockholm from his *Small World* series (1995). Resembling a "botched" tourist shot, Phillips writes, this photograph of Stockholm's elegant main square captures "the round ball of a woman's red hair, and the hilarious appearance of smoke from her purse" (Phillips 2013: 13).

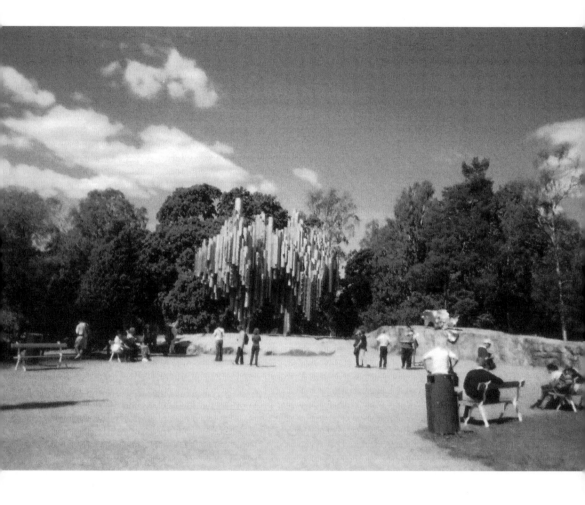

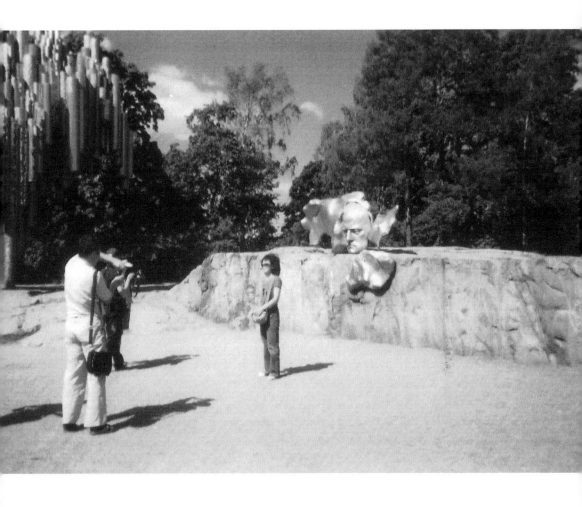

The Sibelius Monument, dedicated to Finland's national composer Jean Sibelius (1865–1957), is made of hundreds of hollow steel pipes. This abstract work by Eila Hiltunen, unveiled in 1967, initially received a cool response from traditionalists, who insisted on adding a figurative representation of the celebrated composer. Contemporary tourists happily take pictures with both the abstract pipes and the figurative statue.

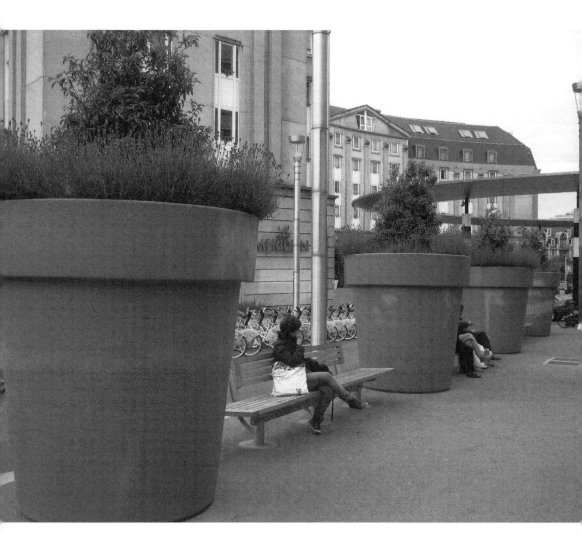

Hide and Seek Brussels

My first photographs of Brussels date back to about 2007, by which time I had become fully accustomed to digital technology. I even began to appreciate some of its advantages, such as being able to travel light. "Visible things always hide other visible things," declares the celebrated Belgian artist René Magritte (Magritte, cited in Alden 1999: 95).

With its fondness for paradox, Brussels itself encourages you to discover greatness in unexpected places. Near Gare Centrale (the Central Train Station), located in the heart of the city, I photographed gigantic flower pots alluding to Magritte, who strived to "make the most everyday objects shriek aloud" (Alden 1999: 46). In Magritte's painting *The Listening Room* (1958), a giant green apple takes over an entire room. *The Wrestler's Tomb* (1960) depicts a similarly enormous red rose, except the room is now painted deep red.

The Mont des Arts building, also located near the Central Station, is decorated by an unusual puppet clock. Unlike the puppet clock on the façade of the Obraztsov Puppet Theatre in Moscow, the Brussels clock uses "human" puppets representing historical figures and folklore characters. The director Sergei Obraztsov felt that the "human" puppets, such as Sleeping Beauty, "would appear odd" inhabiting a clock (Obraztsov 1981: 427). On one of my visits to Brussels, the hands of the Mont des Arts clock had been removed, apparently because of some malfunction. I thought about Lewis Carroll's *Alice's Adventures in Wonderland*, in which time is forever frozen at 6pm, the official tea-time. "It's always tea-time," laments the Hatter, "and we've no time to wash the things between whiles" (Carroll 1992: 457).

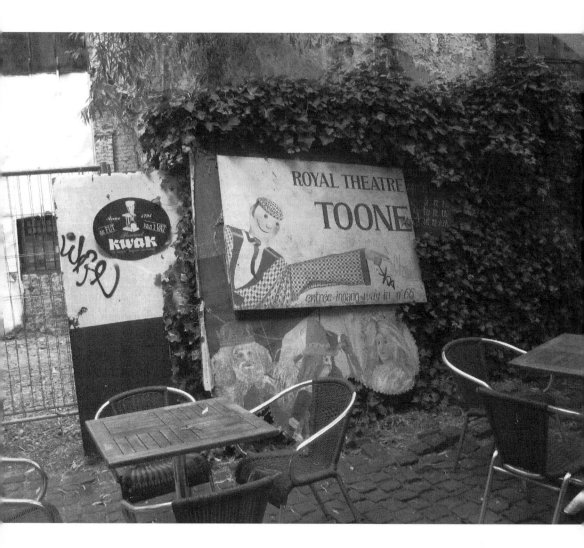

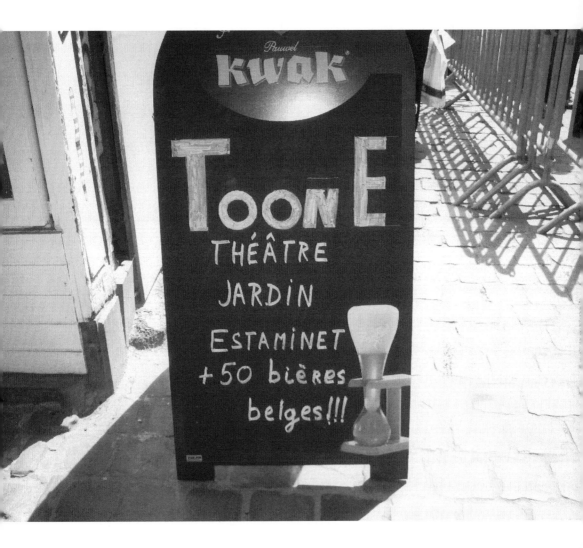

Maison de Toone (The House of Toone) on rue du Marché aux Herbes incorporates a pub and a marionette theatre, as well as a marionette museum. The theatre is located on the upper floor and is not immediately apparent. This legendary establishment also supports Magritte's observation about how "visible things always hide other visible things."

The flamboyant rue de Marché aux Herbes, leading from the Central Station to the landmark square Grand Place, attracts many street musicians from around the world. The elegant Grand Place is off limits to these vagabond performers.

The revered Théatre Royal de la Monnaie, constructed in 1700 and rebuilt in 1819, is more commonly known as La Monnaie (The Mint). Its pristine neo-classical architecture makes no visible reference to an old mint that once occupied this site. Brussels' most striking venue is the Art Nouveau building of the Royal Flemish Theatre, abbreviated the KVS. The friendly staff at Waterstone's, the city's largest English-language bookstore, strongly recommended the KVS as an architectural marvel and provided a handwritten address. In return, I purchased a vintage edition of *The Wizard of Oz*.

Brussels puts you in the mood for books combining real and imaginary worlds. Dennis Kilfoy, a friend and a graduate student, pointed out that the Hollywood adaptation of *The Wizard of Oz* (1939) uses colour and black-and-white footage to separate one reality from another. He added that Eisenstein has also employed this strategy in his ill-fated film *Ivan the Terrible Part II*, released with a considerable delay in 1958. Brussels often neglects to provide any such markers, and instead it presents the visitor with startling contrasts.

Walking to the KVS, I photographed the minimalist National Theatre, its glass façade reflecting Brussels' cloudy sky. Located a short walk away, the sumptuous KVS, with its many statues and balconies, came as a complete surprise. According to the theatre's official website, the ornate balconies were made to provide spectators with an easy escape in the event of fire. At the time of the building's reconstruction in the late nineteenth century, several theatres in Europe suffered from horrific fires, which claimed many lives. Originally constructed as an arsenal store, the KVS was converted into a theatre by the architect Jean Baes, who trained the celebrated Art Nouveau artist Victor Horta. Across the street from the KVS, I photographed the modest Théatre Arte decorated with remarkable graffiti depicting cyber dogs and demons.

Theatre buildings and their locations, Marvin Carlson argues in his *Places of Performance* (1989), "generate social and cultural meanings of their own which in turn help to structure the meaning of the entire theatre experience" (Carlson 1989: 2). Carlson refers to Roland Barthes, whose essay "The Eiffel Tower" (1979) identifies the meaning of several important "zones" of Paris, such as the Opéra, the Pantheon, and Montmartre. Extending Barthes, Carlson writes that the "location of theatres within Parisian text reflects these rough connotative divisions with perfect accuracy" (Carlson 1989: 13). "In the Montmartre 'pleasure' district," he points out, "we find clustered the cabarets and music halls" (Carlson 1989: 13).

In Brussels, theatre locations do not always reflect accurately the city's "connotative divisions." For example, the sumptuous Royal Flemish Theatre (KVS) contradicts its rather rundown surroundings. Similarly, the stately park Parc royal Warandepark, with its prominent fountain and many statues, both complements and overshadows the Theatre Royal du Park.

Konstantin Stanislavsky, the famous founding director of the Moscow Art Theatre, complained about his sojourn in the poorly kept Hermitage Gardens – a legendary amusement park in Moscow, incorporating several theatres. He writes that the Gardens' indoor theatre was "dirty, dusty, ill-constructed, with the smell of beer and some sort of acid that had remained from the summer uses of the building" (Stanislavsky 1952: 325). Stanislavsky was also critical of the owner Yakov Shchukin, who failed to maintain "fine moral tone" and provide a family-friendly atmosphere in the Hermitage. The attractive and well-maintained Theatre Royal du Park in Brussels would delight Stanislavsky. Its only drawback is its out-of-the-way location on the park's northern edge. The Brussels Park also has a secluded outdoor stage, rendered virtually invisible by the overgrown nature.

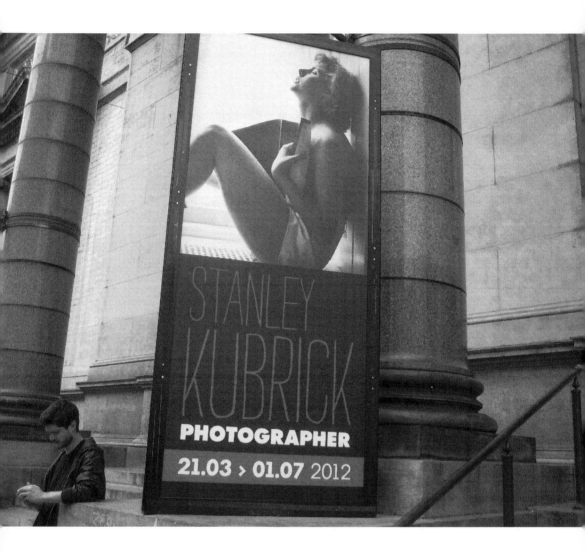

The front entrance of the Musées Royaux des Beaux-Arts, Brussels' fine arts museum, displayed a framed poster advertising an exhibit of Stanley Kubrick's photography. A sensual portrait of a young woman, reminiscent of his film *Lolita* (1962), this image represents Kubrick's unique take on the post-World War II United States. In *Regarding the Pain of Others*, Sontag writes that a photograph is "always an image that someone chose; to photograph is to frame, and to frame is to exclude" (Sontag 2003: 46). While commonly perceived as documentary evidence, photographs, Sontag argues, "offer a subjective take on reality" (Sontag 2003: 46).

Wim Wenders, the celebrated director of *Paris, Texas* (1984) and *Far Away, So Close* (1993), similarly points out that the camera "allows the photographer at the very moment of shooting to be in front with the subjects, rather than separated from them" (Wenders 2010: 13). An avid photographer, Wenders writes in his book *Once* that "every photograph is also the beginning of a story starting 'Once upon a time [...]'" (Wenders 2010: 13).

Over the years, I have collected many pictures and stories in Brussels. I leave out with regret the landmark square Grand Place, my remarkable room at the Metropol Hotel with the wallpaper resembling a theatrical backdrop, and the quirky Café Nero near the suburban Groenendaal station, commemorating Marc Sleen's comic *The Adventures of Nero and Co.* Like the point of view from which I take pictures, my selection of images is often subjective, though sometimes selecting images is simply a matter of arithmetic – there is never enough room for everything, and something inevitably has to be subtracted.

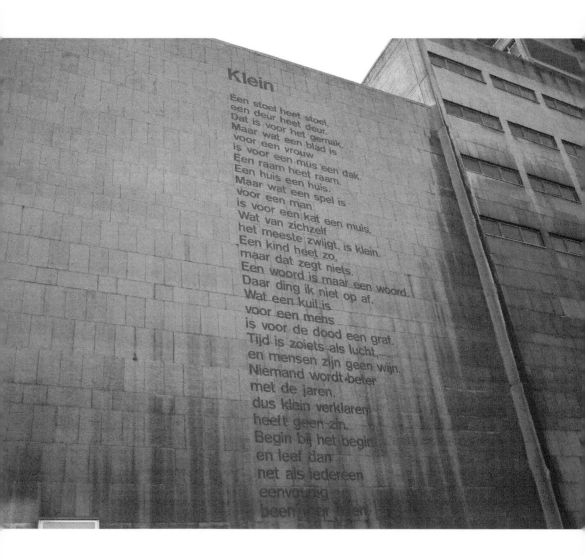

Antwerp Writing on Walls

In Antwerp, I photographed Bart Moeyaert's poem inscribed directly on the wall of the Stadsschouwburg (Theatre City) complex. According to Piet Defraeye, my Belgian university colleague from the Department of Drama, most locals dislike the Stadsschouwburg for its functional 1980s architecture, and consider it an eyesore. Piet first took me to see a number of more "worthy" attractions, among them the old-fashioned Toneelhuis Theatre, with its posh top-floor restaurant.

The ugly duckling Stadsschouwburg came last on our tour. In *Empire of Signs*, his imaginary take on Japan, Roland Barthes writes that "an unknown language constitutes a delicious protection" to a foreigner (Barthes 1994: 9). I share Barthes' fascination with experiencing life "in the interstice, delivered from any fulfilled meaning" (Barthes 1994: 9). However, in Antwerp I desperately wanted to know what that Flemish wall poem was about. Reproduced boldly in red paint, it seemed to communicate something important.

I later learned from the translation by Piet and his friend Mike Devos that it discusses the incongruity between words and objects – a subject also frequently addressed in the art of Magritte. In his well-known painting *The Interpretation of Dreams* (1927), Magritte assigns contradictory names to each of the represented objects. An image of a suitcase sports a caption reading "sky," while an image of a leaf is identified as a "table." Moeyaert's poem follows a similar logic: "But what is a leaf/ To a woman/ Is a roof to a sparrow" (Defraeye and Devos 2012). Possibly because of its title "Klein" (small), the poem is inscribed on the façade of the Hetpaleis (the youth theatre), part of the Stadsschouwburg complex. But it can also be read as a statement on the art of theatre as a whole, which, like language, is often at odds with the "real" world.

A large covered space in front of the Stadsschouwburg (Theatre City) performing arts centre in Antwerp. No clutter here: pavement and sky.

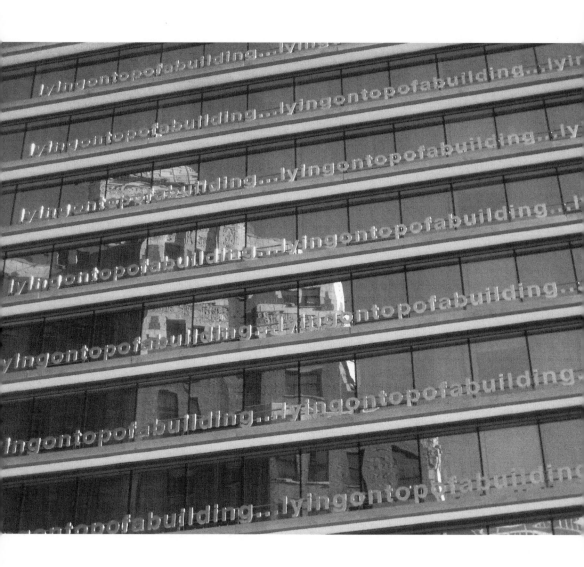

Vancouver in Plain Air

In Vancouver, a poem by the British conceptual artist Liam Gillick is reproduced on the exterior of the Fairmont Pacific Rim Hotel, a recent 22-storey addition to the Fairmont chain in this city. I first learned about it from a blurb in *enRoute*, the Air Canada in-flight magazine, which quotes Gillick's short poem in its entirety:

> Lying on the top of a building the clouds looked no nearer than when I was lying on the street...

> *(enRoute* 8. 2011: 24)

When you see it live, the poem does not seem short at all. Reproduced multiple times on the hotel's exterior, it appears to go on and on like *One Thousand and One Nights*. Deciphering it is not easy either: it is too high up, and the text is obscured by the surrounding architecture and Vancouver's lush trees reflecting in the hotel's glass surface.

Gillick's work tends to be "fluid, refusing to rest in any one place or time," Charlotte Bonham-Carter and David Hodge write in their volume on *Contemporary Art* (Bonham-Carter and Hodge 2013: 142). They cite Gillick's installation *Presentism* (2005), in which "short texts were hung from the ceiling of a gallery" (Bonham-Carter and Hodge 2013: 142). As the viewer moves around the gallery, "the texts appear to alter, merging with one another and forming different structures" (Bonham-Carter and Hodge 2013: 142). "This incorporates [the viewer's] actions into the syntax of the work," the critics argue, "but also emphasizes time, with the work constantly shifting through the course of its exhibition" (Bonham-Carter and Hodge 2013: 142). In Vancouver, Gillick's poem is also "defused throughout time and space," encouraging the viewer to "rethink the status of artworks," and, equally important, to re-evaluate the hotel's space itself and begin to read it "textually" (Bonham-Carter and Hodge 2013: 143).

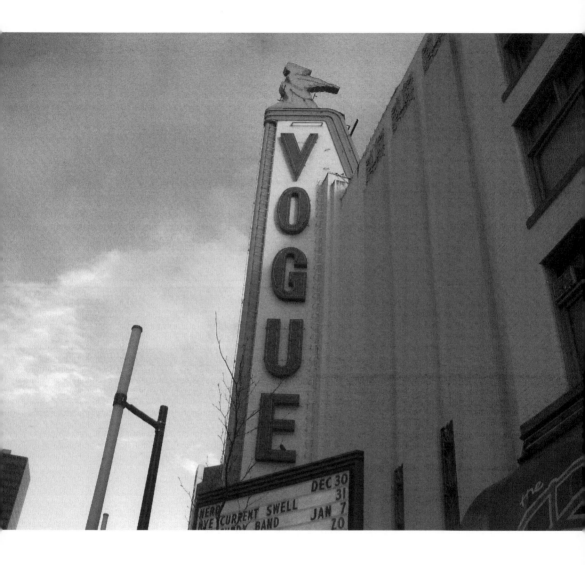

Douglas Coupland's *City of Glass* (2009), one of the best sources on Vancouver, contains numerous entries on this city's spectacular nature from birds to salmon to Mount Baker. Combining short texts and images, Coupland's book also includes two longer narratives. In one of these, he describes Lions Gate Bridge, where he once witnessed a spontaneous performance that brought the traffic to a stop. Standing on the roof of a white Cadillac, "a bearded man in a white suit" was playing a horn, "serenading the jumper on the bridge with 'Stranger on the Shore'" (Coupland 2009: 116). Coupland narrates several other stories connected to this bridge – "a structure so potent and glorious that its existence in your mind becomes the actual architecture of your mind" (Coupland 2009: 113).

Vancouver's indoor theatres receive little attention in Coupland's book. In this city, governed by the ocean and mountains, even the flourishing film industry, Coupland writes, "doesn't seep into daily life the way it does in Los Angeles" (Coupland 2009: 6). I photographed some theatres on Granville Street, including Orpheum, built as a vaudeville stage in 1921, and the neighbouring Vogue, constructed in the 1940s as a cinema. With their original neon signs, these venues stand in sharp contrast to Vancouver's modern, "city-of-glass" architecture.

Coupland's book reproduces a number of Fred Herzog's nostalgic photographs of Granville from the 1960s. His 1959 picture captures both Orpheum and Vogue, as well as several other venues that no longer exist. "Lest we get too sentimental for the recent past," Coupland cautions, "let's remember its air pollution and its visual pollution" (Coupland 2009: 129). Commenting on Herzog's image of Granville from 1966, Coupland points to "the blackened roof of the Hotel Vancouver," and the hotel's unnecessary large sign – "thank you, large red sign, for telling us what the building is!" (Coupland 2009: 129).

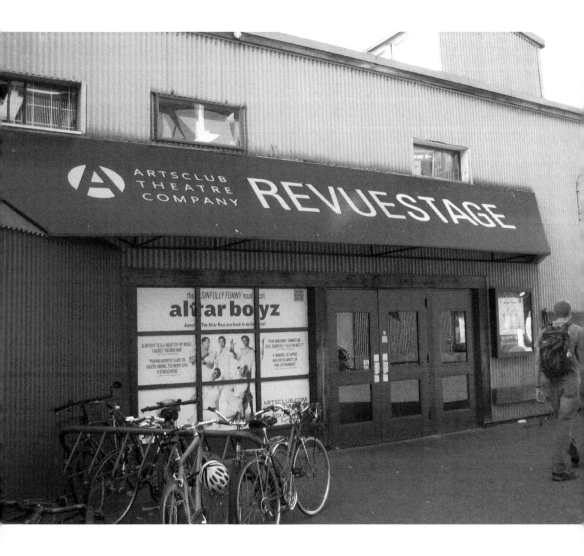

The picturesque Granville Island, with its popular seafood market, is the location of the Arts Club Theatre Company and its two contrasting stages – the understated Revue Stage, and the tall Granville Island Stage, resembling at once a barn and a boat.

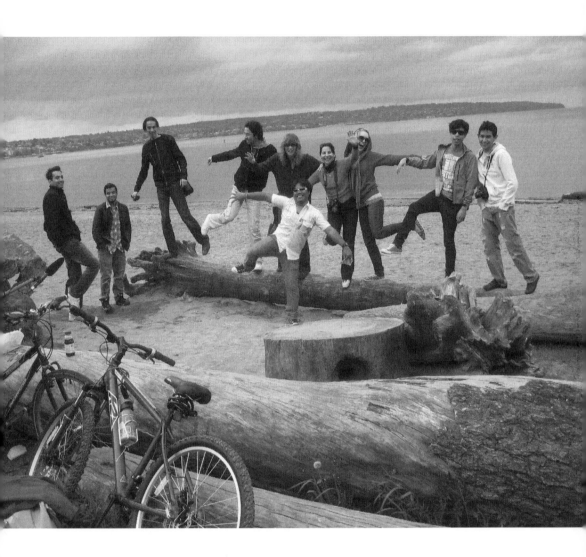

Vancouver's protagonist is the ocean. This is where all of the action takes place: walking, riding bikes, posing for pictures. The poet Marina Tsvetaeva, a contemporary of Boris Pasternak, has compared the sea to a "monstrous *saucer*" (Tsvetaeva 1985: 199). According to Tsvetaeva, mountains encourage participation, whereas the sea turns a person into a mere spectator. She writes in a letter to Pasternak: "The sea is a dictatorship, Boris. A mountain is a divinity" (Tsvetaeva 1985: 199).

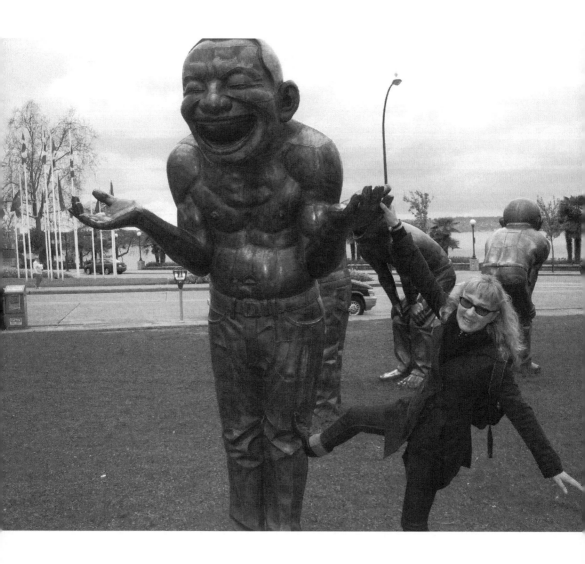

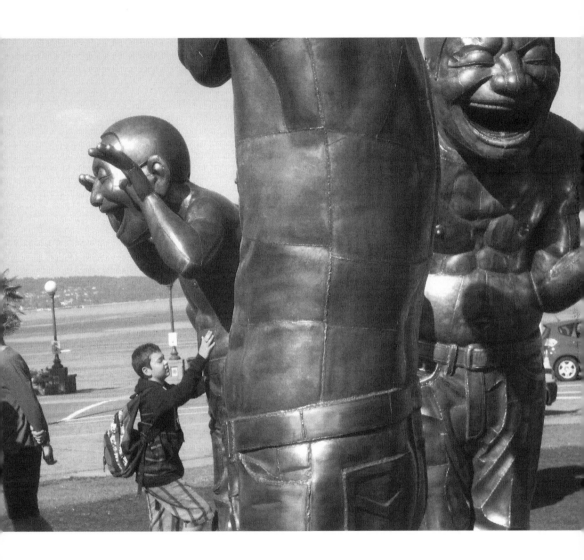

A-maze-ing Laughter by Yeu Minjun near English Bay in West Vancouver was initially installed for the 2009–2011 Biennale. Thanks to a private donation, these happy statues have remained in the city. According to *The Globe and Mail*, the Beijing-based Yeu Minjun agreed to an "extraordinary price reduction" upon seeing pictures of people interacting with his work (Lederman July 24, 2012: R3).

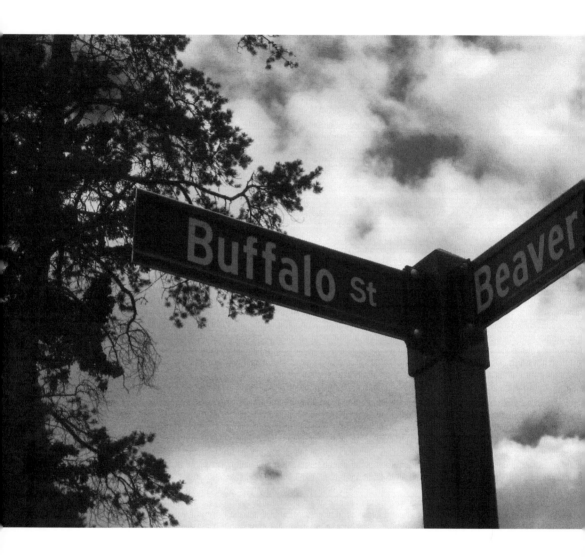

Alberta Outdoor Challenge

Nature also plays the principal role in Banff, a resort town located in the Canadian Rocky Mountains, about an hour drive from Calgary, Alberta. I photographed the street sign at the intersection of Buffalo and Beaver streets while walking to the Banff Centre, the site of the recently constructed Shaw Auditorium. Unveiled in 2011, this modern venue has replaced the centre's unfortunately placed old amphitheatre, where glorious mountain sunsets tended to blind spectators. According to *The Globe and Mail* newspaper, in the new auditorium "the audience is facing due south, with the sunset now visible only out of the corner of their eyes" (Lederman 2011: R3). *The Globe* also reports that a "rainier-than-usual spring and summer" delayed the construction, forcing changes in the inaugural concert programme (Ledereman 2011: R3).

"But we must not forget that the meaning of 'open air' is its fragility," Roland Barthes warns in his essay on the ancient Greek theatre (Barthes 1985: 79). The open-air show, Barthes points out, presents spectators with many external disruptions, such as "shifting sun, rising wind, flying birds, noises of the city" (Barthes 1985: 79). Barthes adds that in ancient theatres, with their 14,000-seat auditoriums, the public "is itself transformed by its very mass" (Barthes 1985: 79).

The much smaller Shaw Auditorium in Banff, accommodating only several hundred spectators, with some additional seats on the grass slope, is made to complement nature, not compete with it. I was surprised by how diminutive it looked against the surrounding mountains. Using Rodchenko's avant-garde angles, I did my best to make it appear grander in the pictures.

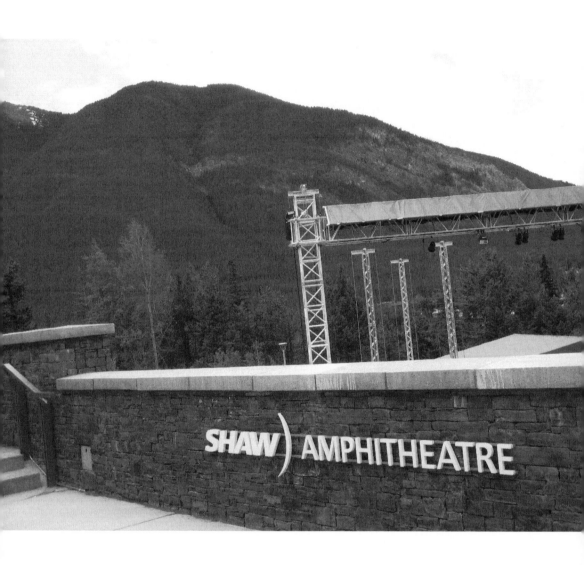

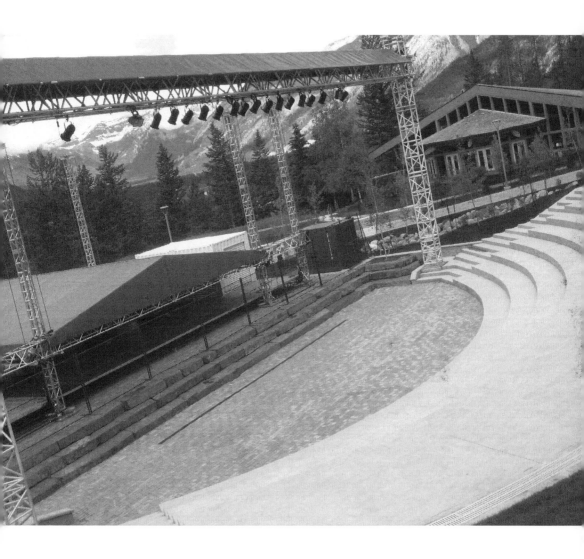

Driving back to Calgary, I surrendered to the environment and began taking pictures of the mountains. Surveying images of nature in *Photography: A Cultural History* (2006), Mary Warner Marien refers to, among others, the American photographer John Pfahl, who "has been cleverly undermining landscape views with additions that prevented viewers from easily comprehending the spatial relationships before their eyes" (Warner Marien 2006: 474). In Pfahl's image "Australian Pines" (1977), Warner Marien writes, "the sea looks like flat blue ribbon stretched across the trees" (Warner Marien 2006: 474).

"Whereas Pfahl constructs physical impediments to seeing in a landscape view," Warner Marien continues, "some photographers exploit obstructions that were already there, especially the automobile" (Warner Marien 2006: 474). Canadian Edward Burtynsky, she points out, focuses on "landscapes made spectacular through pollution, mining, and industrial decay" (Warner Marien 2006: 475). Prefacing his *Globe and Mail* interview with Burtynsky and the Brazilian photographer Sebastiao Salgado, Robert Everett-Green writes that both of these artists "have built international careers from staking out positions on the front lines of industrial globalization" (Everett-Green 2013: R1).

While sharing a number of preoccupations, Burtynsky and Salgado, the interview reveals, follow some divergent working strategies. Describing his approach, Burtynsky states: "When you develop a concept that you want to follow, you move away from the randomness of taking pictures to the idea of making pictures" (Everett-Green 2013: R10). Salgado replies: "You try to prepare yourself, and you may have a good notion of where you are going, but you don't know exactly what you will find" (Everett-Green 2013: R10). Like Salgado, I believe that there is always "the moment of surprise when you discover things as they really are in that place" (Everett-Green 2013: R10). My visit to Banff has provided further evidence of this. Contrary to my expectations, the dialogue between the new theatre and the mountains around it was rather lopsided, with the latter participant more or less stealing the show.

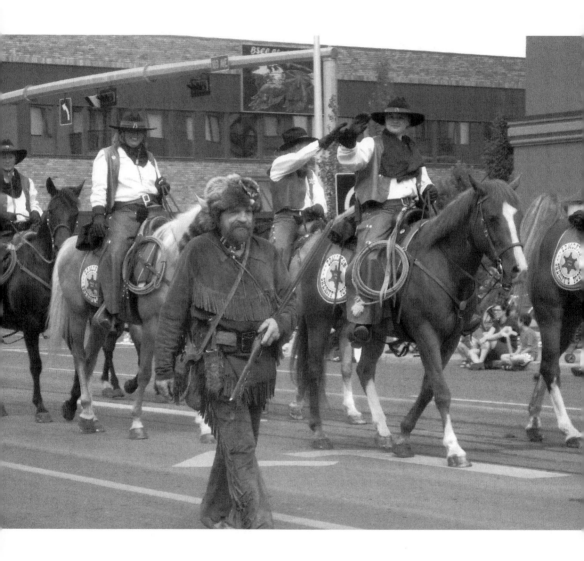

In Edmonton, the capital of Alberta, the most significant force of nature is the giant sky. I like to photograph it from my window, in which the downtown high-rises look like toy models against Edmonton's big sky. In *City of Glass*, Douglas Coupland writes that when flying back to Vancouver, he looks from his seat for the sight of his beloved Lions Gate Bridge – a sight, he adds, "I need to see in order to make myself feel I am at home again" (Coupland 2009: 118). From a plane, the view of Edmonton is more frequently that of an uninterrupted white solitude – miles of flat land covered with snow. Here, winter begins in October and departs reluctantly towards the end of April. Street parades are scheduled for July and August, offering occasional heat.

Many parades take place on Jasper Avenue, the city's main thoroughfare, and one of only a handful of streets designated with a name, rather than a number. In "Word and Image," Eisenstein complains that he "found it very difficult to remember the images of New York's [numbered] streets and, consequently, to recognize the streets themselves" (Eisenstein 1969: 15). Like Eisenstein, I am more used to "streets with names," which, Eisenstein points out, "at once bring up an image of the given street" (Eisenstein 1969: 15). Although designated with a name, Jasper Avenue, populated by the usual office towers and residential high-rises, does not differ significantly from other downtown streets.

In Moscow, parades are staged on Red Square, where the Kremlin towers and St Basil's cathedral provide a stunning backdrop. In contrast to Moscow, a parade in Edmonton is a much less formal affair. Here, the military and the Royal Canadian Mounted Police march together with cowboys, Indians, and local businesses. Photographing parades in Edmonton, I tend to focus on the exuberant participants, and try to exclude the more mundane surroundings.

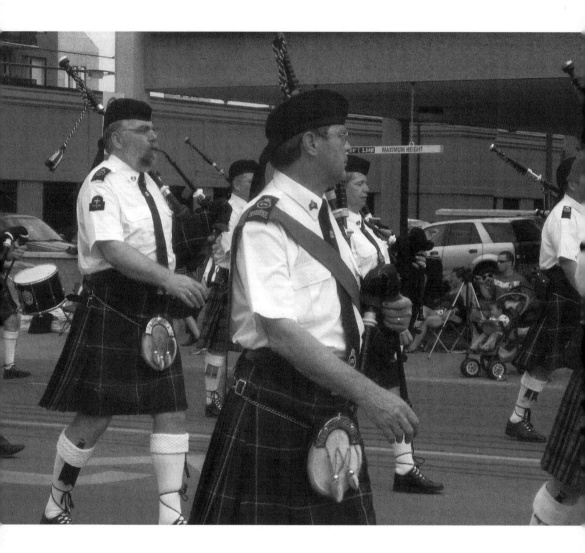

In Edmonton, as elsewhere in Canada, street parades mix the military, ethnic groups, and elaborate commercial floats. Some spectators also choose to dress for the occasion.

Central Park Performing Nature

A cloudy afternoon in New York's Central Park. By the time I reach the Delacorte Theatre, it begins to drizzle, and my pictures acquire a slightly hazy, water-colour-like finish. The Delacorte is another example of an open-air theatre that blends well with its surroundings. Its modest auditorium is visible only from the nearby Belvedere Castle, which is located on a hill and offers panoramic views of this part of Central Park.

In his *Vanity Fair* tribute from 2012, commemorating the Delacorte's 50th anniversary, the playwright Tony Kushner remembers attending a Brecht production, in which Meryl Streep incorporated poor weather into her performance. In spite of rain, "marauding raccoons," and "illusions-shattering helicopters," Kushner insists, spectators have remained loyal to the theatre: "We always come back, because the good nights at the Delacorte have a rare, peculiar magic" (Kushner 2012: 101).

Chekhov, whose plays have also been staged at the Delacorte, addresses the advantages and disadvantages of the open-air theatre in *The Seagull* (1898). In Act One, Konstantin Treplyov defends his outdoor production: "The curtain, the first set of wings, the second set, and beyond that – open space. No scenery at all. You have a clear and open view of both the lake and the horizon" (Chekhov 1977: 7). Treplyov hopes to start the show "just as the moon is rising," and he is worried that Nina Zarechnaya, his leading lady, will arrive too late. His famous actress mother, Irina Arkadina, is against his production altogether, "because she isn't acting in it" (Chekhov 1977: 7). Nina arrives on time, but Treplyov's dark premonitions nonetheless come true. As is characteristic of Chekhov, *The Seagull* leaves the debate on open-air theatre unresolved.

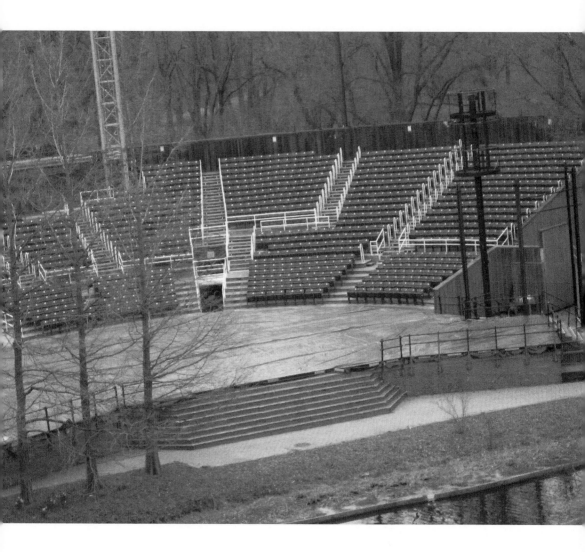

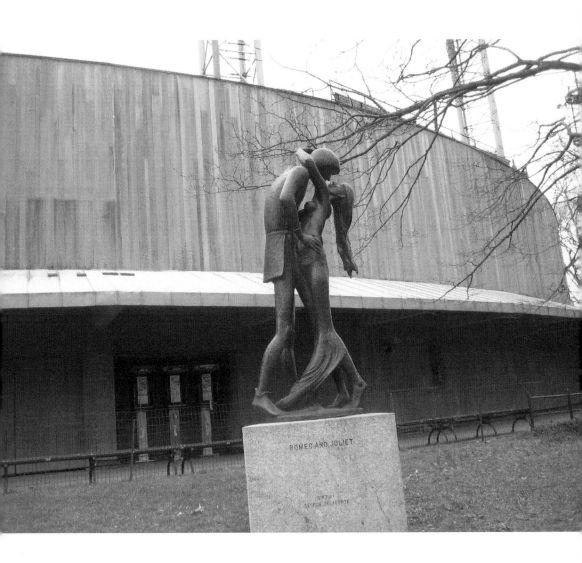

The Delacorte Theatre in Central Park with the statue of Romeo and Juliet. The theatre's open-air auditorium resembling a medium-size baseball diamond can be captured only from the nearby steep hill, the site of the Belvedere Castle.

In Act One of Chekhov's *The Seagull*, Treplyov's outdoor production of his "decadent" play, as his actress mother Irina Arkadina describes it, fails to captivate the audience:

ARAKDINA: It reeks of sulfur. Is that really necessary?

TREPLYOV: Yes.

ARKADINA [*laughs*]: Yes, it's a stage effect.

TREPLYOV: Mama!

NINA: He is bored without humanity...

POLINA ANDREEVNA: [*To Dorn*] You have taken off your hat. Put it on or you're going to catch a cold.

ARKADINA: The doctor here has taken off his hat to the devil, the father of eternal matter.

TREPLYOV [*having flared up, in a loud voice*]: The play is over and done with! Enough! Curtain!

ARKADINA: What is it you're angry about?

TREPLYOV: Enough, that's all! Curtain! Bring down the curtain! [*Having stamped his feet*] Curtain! [*The curtain is lowered*] It's my fault! I lost sight of the fact that only a chosen few can write plays and get them produced in the theatre. I've tried to break into a monopoly! Me... I... [*Wants to say something more, but waves his hand and goes out left*].

(Chekhov 1977: 14)

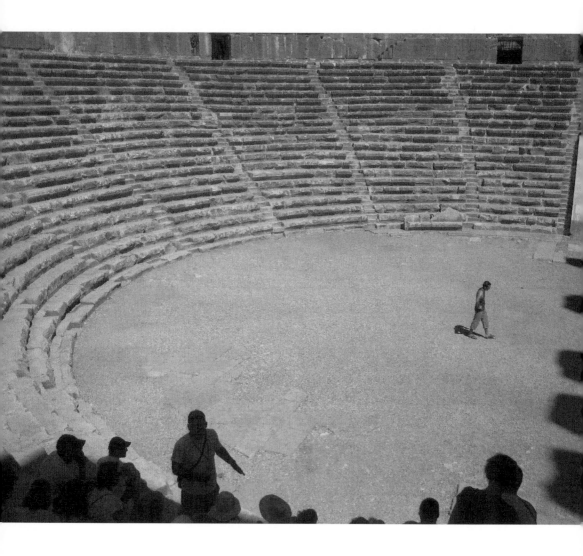

Aspendos Weight of History

The Roman amphitheatre in the Turkish town of Aspendos dominates the environment, rather than blending with it. This giant theatre presents a formidable challenge to a photographer and must be captured either in fragments, or from a bird's-eye point of view. Even the enormous Central Army Theatre in Moscow, which *The Rough Guide to Moscow* compares to the Coliseum and the Acropolis, pales in comparison with it (Richardson 2001: 298).

Completed in 1940, the Central Army Theatre was the first Soviet-built theatre. It has a stage large enough for over a thousand performers, and it can additionally accommodate the weight of heavy military equipment, such as tanks. For its part, the Aspendos amphitheatre, which dates to the reign of Marcus Aurelius in second century AD, overwhelms the visitor not only with its size but also its incomprehensible age.

"There are places where history is inescapable, like a highway accident – places, where geography provokes history," Joseph Brodsky writes in "Flight from Byzantium," his long essay on Istanbul (Brodsky 1987: 406). Brodsky came to Turkey to "find an atmosphere that at present seems to have vanished everywhere else" (Brodsky 1987: 394). His stay in Istanbul proved daunting. He was troubled by dust, as well as his pen's inability to cope with the "meaning of history" – "this aggregation of races, tongues, creeds" (Brodsky 1987: 426).

In Aspendos, I suffered from the oppressive heat. However, even the heat was a distant second to my mind's feeble attempts to grasp the age of the landmark in front of me. To capture the feeling, I photographed my fellow tourists, who looked like specks against the theatre's never-ending rows of stone seats rising high into the cloudless sky of Aspendos.

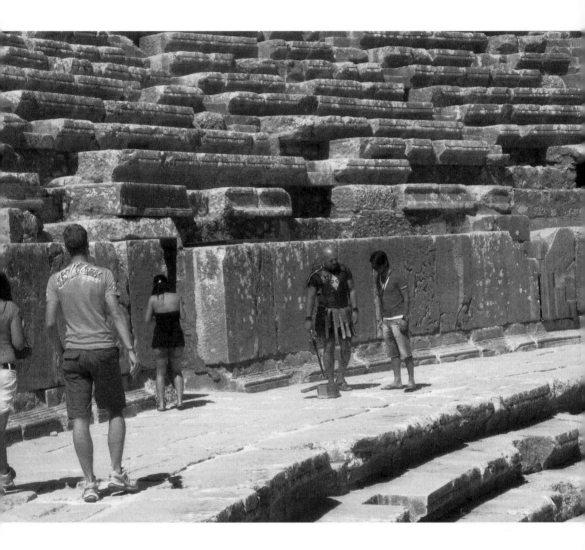

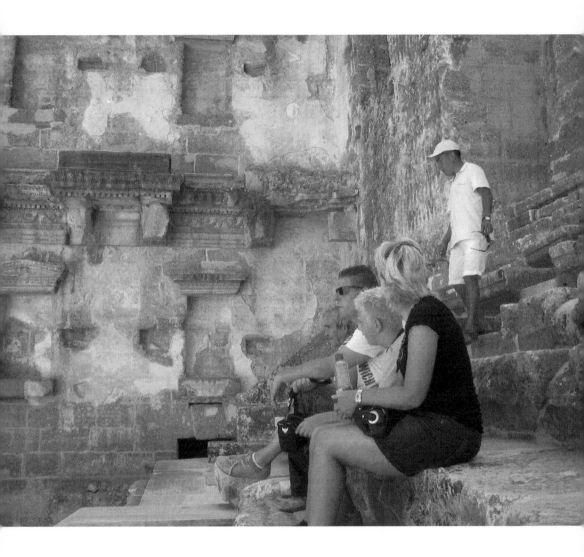

In "Flight from Byzantium," Joseph Brodsky writes that the erosion of ancient monuments "has nothing to do with weathering. It is a pox of stares, lenses, flashes" (Brodsky 1987: 442).

Mexico Tender and Brutal

Eisenstein was in awe of "the cosmic timelessness of Aztec pyramids" (Eisenstein 1995: 414). He adds: "My atheism is like that of Anatole France – inseparable from adoration of the visible forms of a cult" (Eisenstein 1995: 414). In the early 1930s, Eisenstein travelled to Yucatan to shoot a film under the working title *Qué viva México!* The author Upton Sinclair, who proposed this title, supported Eisenstein's project with great enthusiasm and gathered a group of investors for it. Officials from the Mexican Film Trust insisted that the film should remain apolitical, and they were frustrated with the Russian director taking too long to complete his picture.

Eisenstein shot thousands of feet of film, capturing Mexico's "lagoons and plateaux, desserts and undergrowth," as well as its golden "dawns and sunsets," and "succulent fruit with unheard-of-names" (Eisenstein 1995: 413). In "My Encounter with Mexico," Eisenstein writes: "Eden was not somewhere between the Tigris and Euphrates, but here, somewhere between the Gulf of Mexico and Tehuantepec!" (Eisenstein 1995: 413). However, he also acknowledges the darker side of this paradise: "Mexico is tender and lyrical, but brutal too" (Eisenstein 1995: 419). During the civil war, Eisenstein points out, people were shot and left to die in the desert, tied to the "sharp spines of cactus" (Eisenstein 1995: 419). Those "sharp spines," he writes, still pierce the worshippers, who bind "cacti trunks into a cross," and crawl "for hours up the pyramids to glorify the Catholic Madonnas" (Eisenstein 1995: 419).

Eisenstein did not complete his film. Years later, his associate Grigori Alexandrov produced a version of *Qué viva México!* (1979), based on Eisenstein's original footage. The film reveals that, contrary to the Mexican officials' stipulation, Eisenstein intended to include a strong political element related to wars, revolutions, and cruel regimes.

In *Mexican Postcards*, Carlos Monsivais writes that "between 1910 and 1917 the revolutions last all day, all year, and as long as they last the revo' is an organic mixture of historic events and everyday life" (Monsivais 1997: 6). Composing his narrative in the style of Eisenstein's montage, Monsivais further observes: "the military conflict becomes a (non-hierarchical) succession of horses, cannon, dust, a desire to escape the chaos which should not be confused with flight" (Monsivais 1997: 7). Informed by Eisenstein and Monsivais, I have discovered some signs of rebellion in my seemingly benign snapshots of a small town near Puerto Vallarta from some summer a long time ago.

Jaffa Art of Seating

Visiting Jaffa, located on a steep hill overlooking Tel Aviv, I discovered the intimate Hasimta Theatre. Housed in an old fortress-like building, it includes a café, a diminutive stage under the open sky, and a makeshift auditorium furnished with bright living-room couches. An ancient port dating from the Bronze Age, Jaffa is now a Tel Aviv suburb. Here, history does not crush you with its immense weight. Near Jaffa's main parking lot, visitors were taking pictures with a cardboard Napoleon statue, also serving as a street sign.

In Tel Aviv, I stayed near Rothschild Boulevard, which leads to the imposing Habima National Theatre, and the Mann Auditorium, also a large modern structure. The boulevard itself is cosy and unpretentious: small cafés, a McDonald's, some neighbourhood shops, and rows of benches amidst tropical flowers and tall trees with bare trunks. On the nearby Allenby Street, a red plastic chair, placed randomly in the middle of a sidewalk, looked like an improvised stage for a one-man show.

I also photographed graffiti, billboards, street signs, and advertising kiosks. Once again, the unknown language created an obstacle, but it also provided a shield, or a "delicious protection," discussed by Barthes in his book on Japan (Barthes 1994: 9). At the Café Sheleg on the corner of Allenby and Geula, I learned that "sheleg" means "snow," and rejoiced at finding some affinity with my homeland. The word "hasimta" translates as an "alleyway" – a fitting name for the Hasimta Theatre with its haphazard selection of furniture.

My title for this entry alludes to the travelling exhibit *The Art of Seating: 200 Years of American Design.* Organized by the Museum of Contemporary Arts in Jacksonville, Florida, the show features, among other things, Frank Gehry's cardboard High Stool (1971), best described as both a functional chair and a sculpture. The Rocking Stool (1958) by the sculptor Isamu Noguchi is primarily a work of art.

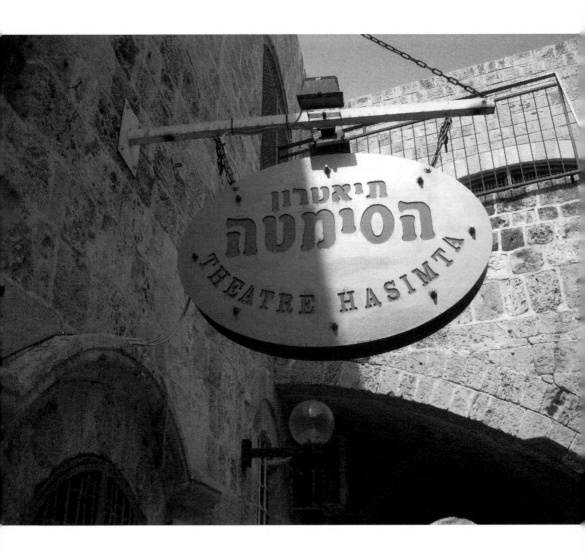

Joseph Kosuth's installation *One and Three Chairs* (1965) incorporates a chair, a photograph of the same chair, and a printout of a dictionary definition of the word "chair." Kosuth instructs galleries to select a chair, take a picture of it, enlarge it, and then display it on the wall to the left of the chair. His work, Daniel Marzona writes in *Conceptual Art*, derives from Kosuth's "particular interpretation of the ready-mades," as well as some aspects of positivist linguistic philosophy, which "strictly rejects any relationship with reality" (Marzona 2006: 18). Marzona points out that following his installation with the chairs, Kosuth "quickly pressed forward to purely abstract concepts" (Marzona 2006: 18).

One and Three Chairs already points to Kosuth making this transition: in real life, chairs do not usually come with a set of instructions. Beyond Tel Aviv's red plastic chair, I have photographed festive deck chairs in London's Hyde Park, where they can also be moved at will – a theatre of improvisation. The more monumental benches lining the River Thames are placed on elevated platforms, and they must be shared as well – an ensemble theatre.

Stanislavsky, a strong advocate of the ensemble theatre, insists that every actor must play a variety of roles: "There are no small parts, there are only small actors" (Stanislavsky 1952: 298). He declares: "One must love art, and not one's self in art" (Stanislavsky 1952: 298). This dictum continues to dominate the Russian stage, as well as the street, offering only benches. The Luxembourg Gardens in Paris, where I first encountered individual chairs, came as a complete surprise.

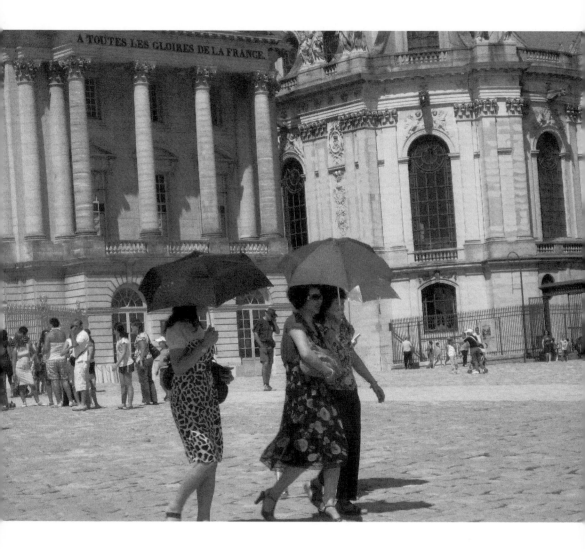

Umbrellas of Versailles

A group of tourists with umbrellas near the entrance to Versailles. There are few places here to hide from the hot afternoon sun: pruned trees resembling statues, and blinding white sand.

I came to Versailles in hope of finding some traces of Kuskovo, an eighteenth-century estate in Moscow, modelled after this French landmark. Founded by Count Boris Sheremetev, a distinguished general under Peter the Great, Kuskovo flourished with Count Peter Sheremetev, Boris' son, who transformed it into a miniature replica of Versailles. In addition to French geometrical gardens, Kuskovo included a lavish indoor theatre, rivalling prominent venues in the centre of Moscow. The Sheremetevs also staged magnificent outdoor celebrations, attended by 25 to 50,000 participants. Restored to its original glory in the post-Soviet period, this former aristocratic estate has now become a popular tourist destination, featuring the only example of the classical French garden in Moscow.

The original Versailles, with its blinding white-sand promenades, turned out to be incomparably larger than I had imagined. It would take several days, if not months, to survey its grounds. I had only a couple of hours, which I had intended to spend walking leisurely, dropping by gazebos and pavilions, and taking pictures of the famed geometrical gardens. There were no gazebos in sight, nor any wooded areas, as in Kuskovo. The stunning French gardens were enormous, their sophisticated geometry apparent only from a bird's-eye point of view. The queues for admission passes were equally formidable, and I resolved to leave Marie Antoinette's theatre for a future visit. Since its post-Soviet restoration, the Kuskovo estate also began to charge admission. Under the benevolent Sheremetevs, all visitors, the nobles and lower classes alike, attended theatre shows and outdoor celebrations free of charge.

Chekhov's *The Cherry Orchard* (1903) describes the end of the estate culture in Russia and the arrival of the new more pragmatic era of capitalism. Throughout the play, the merchant Yermolay Lopakhin attempts to reason with the landowner Lyubov Andreevna, who is visiting from Paris, and her eccentric brother Leonid Gaev, a billiards enthusiast. Lopakhin's advice on how to avert his friends' imminent bankruptcy falls on deaf ears:

LOPAKHIN: You must come to a decision once and for all – time waits for no one. Surely the question is quite simple. Do you agree to lease your land for summer cottages or don't you? You can answer in one word. Is it yes, or is it no? Just one word!

LYUBOV ANDREEVNA: Who is smoking disgusting cigars out here... [*Sits down*]

GAEV: Things became convenient once they built the railroad. [*Sits down*] We made a short trip to town and had lunch ... Off the yellow into the middle pocket! I'd like to go to the house first and play one game...

LYUBOV ANDREEVNA: You'll have time.

LOPAKHIN: Just one word! [*Beseechingly*] Give me an answer, do!

GAEV: [yawning] How's that?

(Chekhov 1977: 182)

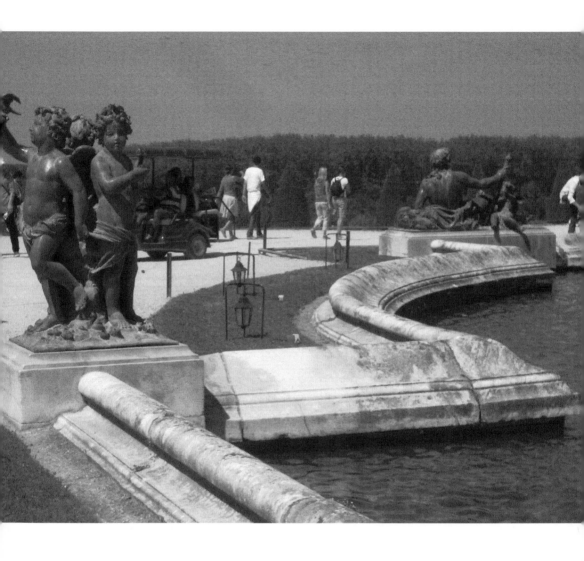

The opposite photograph, depicting a fountain with whimsical statues, is my tribute to Alexandre Benois' series of paintings *Versailles* (1905–1907). In *King's Promenade* (1906), one of the paintings from this series, the king and his entourage, Sergei Parshin writes, "appear more static" than the dynamic bronze statues decorating a Versailles fountain (Parshin 1993: 18). According to Parshin, Benois also contrasts the sky reflected in the fountain and the real sky. The opposite of the genre painting, Parshin argues, *King's Promenade* does not narrate any events, and instead it aims to "freeze the moment" (Parshin 1993: 14). The founding member of the World of Art group, Benois divided his time between his native St Petersburg and Paris, where he designed sets and costumes for the Ballets Russes' productions. Following the lead of Benois and his World of Art colleagues, the Ballets Russes staged mostly ballet and opera – the genres that, Parshin points out, traditionally favour the artifice (Parshin 1993: 20).

Paris Opera Zone of Business

The opulent Opéra de Garnier, constructed for Napoleon III in 1862, is situated in the prestigious 9th arrondissement. An earlier project, Marvin Carlson writes in *Places of Performance*, "would have located [the Opéra] between the Louvre and the Tuileries, but the day for such topographical identification with the king or emperor was now past" (Carlson 1992: 84). Instead, the Opéra was placed "at the centre of one of the representative quarters of the upper bourgeoisie" (Carlson 1992: 84). Its arrival, Carlson points out, "did much to solidify this district as a 'centre de luxe' – a position it retains today" (Carlson 1992: 84). He quotes Roland Barthes, who identifies the Opera area as the zone of "materiality, business, commerce" (Barthes 1988: 13).

Mixing freely the high art of theatre with numerous cafés and shops, Place de L'Opéra is the opposite of Theatre Square in Moscow, which is reserved almost exclusively for theatrical venues. Theatre Square's only incongruous landmark is the elegant TsUM department store dating from the early 1900s, which continues to receive negative criticism for its inappropriate location near the Bolshoi Theatre. In place of cafés and restaurants, Theatre Square offers a sprawling garden with fountains and many benches.

On Place de L'Opéra, where there are no benches, tourists gather on the Opéra's broad entrance staircase. Remembering Rodchenko's lessons, I photographed this magnificent staircase from up-close. In "The Paths of Contemporary Photography," Rodchenko insists that the traditional centred photograph shot from a distance produces "only a gentle spot, the one we are so sick of on all of those postcards" (Rodchenko 2005: 210).

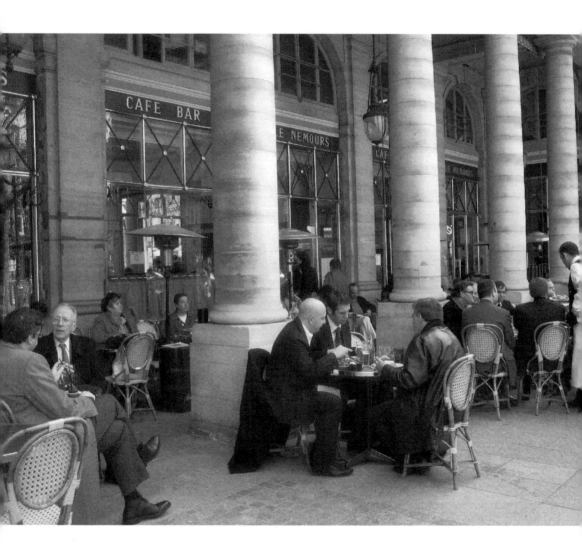

Lunch hour at Café Le Nemours on Place Collette. Located at the bottom of the festive Avenue de L'Opéra, this café offers a direct view of the Palais Royal and the revered Comédie Française, Paris's oldest theatre.

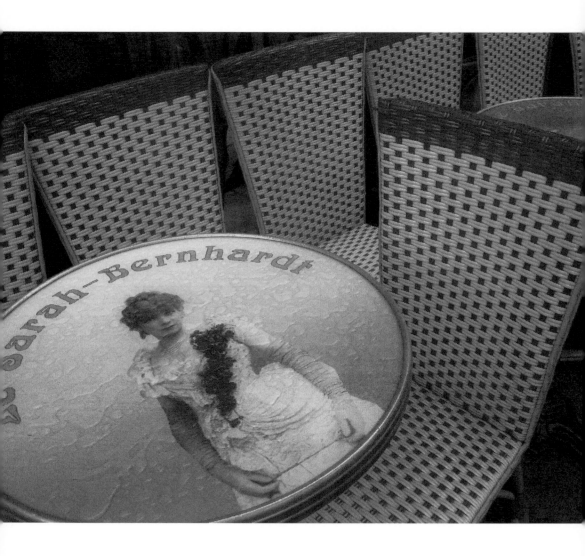

Café Sarah Bernhardt on Place du Chatelet shares space with the Théatre de la Ville. The legendary Sarah Bernhardt (1844–1923), who joined it in 1899, renamed this theatre the Théatre Sarah-Bernhardt. On this stage, she famously performed the title character in the controversial production of Shakespeare's *Hamlet*. Cafés at art galleries and museums, the author Dmitri Prigov writes, offer their visitors some additional profit. In "Accounts with Life," Prigov describes his visits to various such cafés around the world from Moscow to New York. In each instance, he calculates that extra profit gained from having a meal in immediate proximity to high art. At the Tate Gallery in London, his profit earned from the "high-art surroundings" amounted to 20–25 pounds (Prigov 1997: 402). At the Metropolitan Museum in New York, Prigov's bill was "about 15 dollars, but the 'pleasant surroundings' […] increased the value to 50 dollars" (Prigov 1997: 401). Andy Warhol, who hoped to start a chain of diners called *Andymats*, has stated famously: "Making money is art and working is art and good business is the best art" (Warhol, cited in Kuhl 2008: 20).

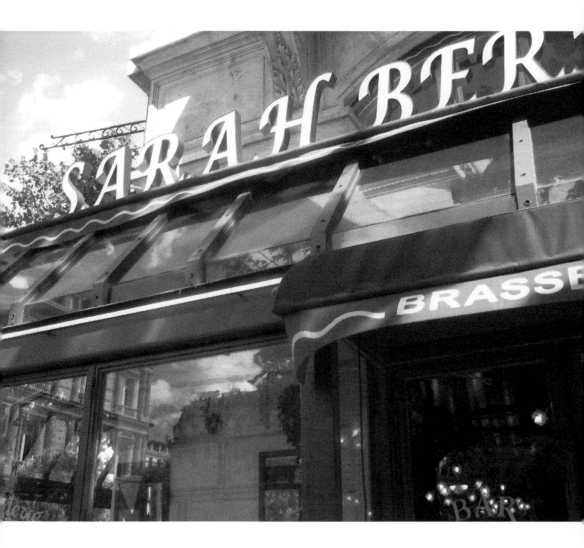

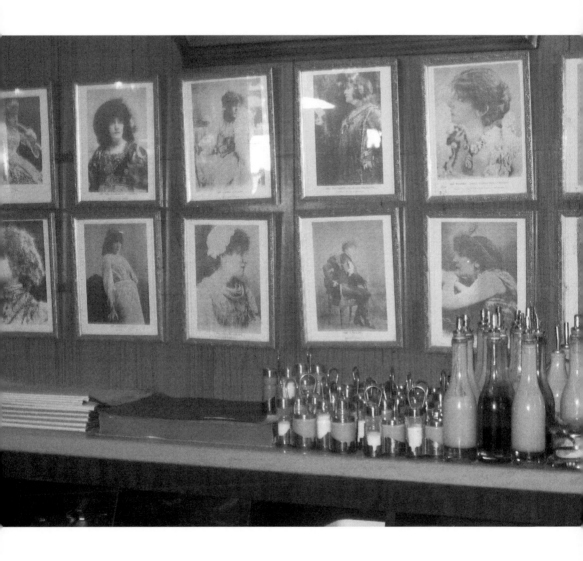

A selection of archival photographs of Sarah Bernhardt in her namesake café. In Moscow, there is still no café named after Maria Ermolova (1853–1928), Bernhardt's Russian counterpart, although there is a riverboat *Maria Ermolova*, which has a restaurant and a bar.

The imposing Opéra de Bastille, unveiled in 1989, has received some strong criticism for its modern architecture. According to *The Rough Guide to Paris*, one critic has described it as a "hippopotamus in a bathtub" (Kabbery and Brown 2001: 68). François Mitterrand's socialist government, Marvin Carlson writes, has intentionally placed this "people's opera" at a considerable remove from "the established Parisian entertainment world, and on a site with the strongest populist associations, Place de la Bastille" (Carlson 1992: 91).

The historical Bastille Square has much in common with Moscow's Taganskaya Square, also a site of an infamous prison in the past. With the arrival of the popular Taganka Theatre in the 1960s, this square has been transformed into an important theatrical destination. Today, the rebellious Taganka Theatre continues to stage provocative shows, reinterpreting such classics as Pushkin and Pasternak. The Opéra de Bastille specializes exclusively in opera – an art form somewhat at odds with its working-class location. The opera, Lev Tolstoy insists, appeals mostly to the decadent high classes. In *War and Peace* (1869), Tolstoy describes Natasha Rostova's bewilderment upon seeing her first opera show:

> She could not follow the opera, could not even listen to the music: she saw only the painted cardboard and the oddly dressed men and women who moved, spoke, and sang so strangely in that brilliant light. She knew what it was all meant to represent, but it was so blatantly false and unnatural that she felt alternately ashamed for the actors and amused by them.
>
> (Tolstoy 1968: 67)

Place de la Bastille on a week-day afternoon. With the arrival of the modern Opéra de Bastille, constructed under François Mitterrand, this historical square, once a site of the infamous Bastille prison, has transformed into a popular tourist destination.

Corporate Arts Toronto

In exchange for its multi-million-dollar donation, the Four Seasons hotel chain has received the perpetual naming rights to the performing arts complex in downtown Toronto, home of the Canadian Opera Company. Inaugurated in 2006, this modern complex has gathered conflicting reviews. While praising its transparent Western façade, allowing interaction with the street, most commentators criticize the sombre architecture of the rest of the complex. Defending his design, the architect Jack Diamond states: "Of course, there is a place for pavilion-like buildings. It depends on where they are, but you do not do it on every block" (Diamond, cited in Mays 2006: 24).

New York's Metropolitan Opera, another modern landmark, saves its more opulent components, such as Mark Chagall's murals, for the inside. The Met's glass walls, Marvin Carlson writes in *Places of Performance*, allow strollers "to glimpse the Chagall murals, though they can be seen better from the inside" (Carlson 1989: 189). Carlson points out that Chagall's murals in New York and Paris, where he painted the Opera Garnier's ceiling, "are closely related semiotically, not only in the general celebration of high culture they represent, but in the specific themes and motifs Chagall employed" (Carlson 1989: 188).

The Four Seasons complex in Toronto, which also pays tribute to high culture, features a lavish auditorium, contrasting with the building's rather reserved exterior. Toronto's answer to Chagall's art is a giant mosaic depicting a crowded hockey arena by Stephen Andrews, displayed at the entrance of the new Trump Tower Hotel on Bay Street.

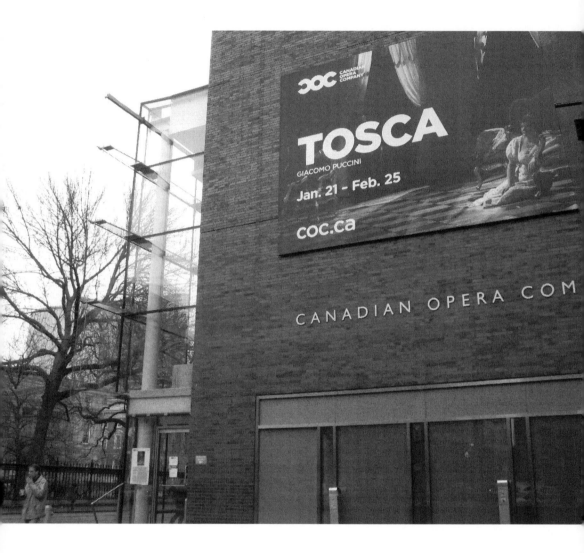

Toronto's Four Seasons Centre for the Performing Arts on a damp afternoon in December. I photographed both the centre's transparent Western façade and the dark-brick walls beyond it. The opposite of the traditional European opera house, this modern structure corresponds well to the tall office towers and hotels that surround it.

Ice Theatre Ottawa

In Ottawa, where I completed my graduate degree, the most prominent stage is the National Arts Centre. This fortress-like building is located near Parliament Hill, the city's chief architectural landmark, and Rideau Canal, which transforms into the world's largest skating-rink in the winter months. Constructed in 1969, the Arts Centre is designed in the Brutalist style – a modernist trend, which advocates the use of angular forms and "brutal" construction material, such as concrete.

The precise geometry of Ottawa's Arts Centre becomes particularly apparent in the winter, when the building's triangles and hexagons stand in sharp relief against the snow and barren trees. I photographed it from the Mackenzie King Bridge, where it resembles a Malevich painting. My nostalgic walk along the canal was cut short by freezing rain and strong wind. Wind was also blowing hard on Parliament Hill, where tourists were taking pictures of the landmark clock tower.

Photography fails to capture either cold or bitter wind. For his extraordinary image *A Sudden Gust of Wind* (1993), the celebrated Canadian photographer Jeff Wall has employed digital manipulation, as well as some live acting. It took Wall five months to complete this elaborate remake of an eighteenth-century coloured woodcut by the Japanese artist Hokusai. Wall staged the image near his studio in suburban Vancouver – a strategy he uses commonly. In *Art and Photography*, David Campany points out that Wall's large-format photographs, which he displays on light boxes, take on a "cinematic quality," and resemble more closely a "frozen piece of film" (Campany 2007: 161). Wall himself has stated that the "spontaneous is the most beautiful thing that can appear in a picture, but nothing in art appears less spontaneously than that" (Wall, cited in Finger and Weidemann 2011: 31).

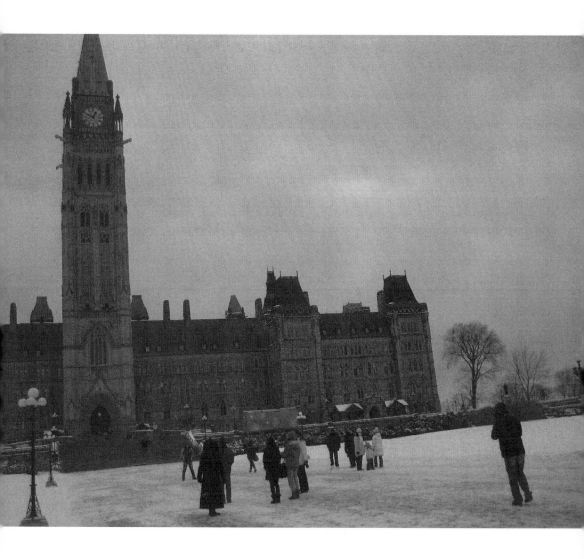

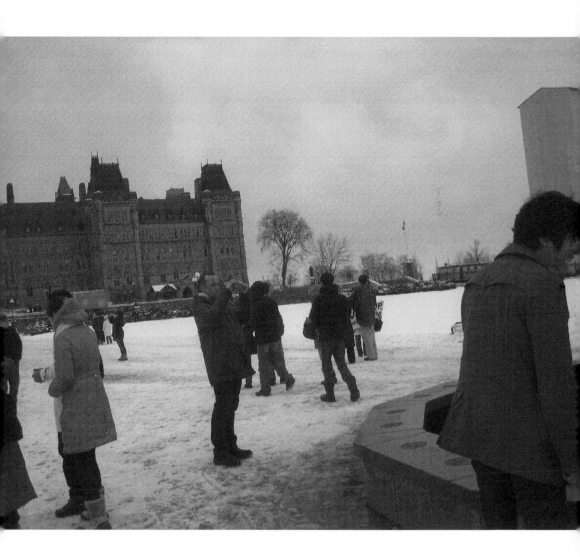

Resilient tourists brave the cold and bitter wind on Parliament Hill in Ottawa.

In *Findings on Ice*, an experimental collection of texts and images by scientists and arists, the mathematician Marjorie Senechal contemplates a passage on snowflakes from Thomas Mann's *The Magic Mountain*: "They were too regular, as substance adapted to life never was to this degree – the living principle shuddered at this perfect precision [...]" (Senechal 2007: 114).

In the same volume, the director Richard Foreman discusses his "ice cold theatre," in which the "spectator FREEZES and then perhaps, as in a scientific experiment, is free to examine his/ her self as observer" (Foreman 2007: 130, original emphasis). He adds: "This, I believe, can lead to aesthetic ecstasy, which is also at its best, a kind of 'ice'" (Foreman 2007: 130).

The contribution by Iman Mersal, a prominent Egyptian poet and my university colleague, is entitled "Memory of *Thalg*." Mersal writes that while it has "hundreds of words to describe all things concerning the desert," Arabic has only one word for both snow and ice – *thalg* (Mersal 2007: 147). In her collage of memories, Mersal refers to, among other things, an indoor beach in West Edmonton Mall, and an "ice resort" in Dubai, "where snow 'falls' all year round," and "people ski on artificial hills" (Mersal 2007: 149). Mersal states: "Perhaps the beach and the snowy hills are among the most modern miracles of global capitalism" (Mersal 2007: 149).

Icy sidewalk of Rideau Canal in Ottawa.

Drama Queen Montreal

Late December in Montreal. A brief visit to take some missing pictures and locate the unusual Centaur Theatre, housed in the former Montreal Stock Exchange building in Old Montreal. My first photograph of the day is a view of Montreal's downtown as seen from my hotel room window: a frozen landscape of modern office towers and residential high-rises.

It is bitterly cold, and the short walk to Old Montreal, about 15 minutes from my hotel, feels two times longer. Looking for the Centaur Theatre, I take some pictures of the local attractions. The frosted window of a stationery shop displays a selection of carnival masks from Venice. The Notre Dame Basilica, this area's most prominent landmark, is decorated with the fragile Christmas lights shaped like angels. I find the Centaur Theatre just off the festive Notre Dame Street. Its imposing façade still displays the name of the old stock exchange. The theatre's name appears only in the bright ads, partially obscured by a row of tall columns decorating the entrance. In Greek mythology, centaur is a hybrid creature, part human and part horse – a name that describes well this peculiar theatre.

Several months later, I come across an article in *The Globe and Mail* newspaper, reporting that the Centaur is "in the midst of an environmental assessment for a proposed renovation" (Taylor 2012: R2). *The Globe* quotes the theatre's managing director, who would prefer to use the money for the productions: "We have a lovely heritage building but we are the plays we put on stage" (Taylor 2012: R2). Natasha Vesselova, who first brought the Centaur to my attention, appears to share this opinion. A fellow Russian living in Ottawa, she admires the Centaur's "настоящий театральный подъезд с колоннами" (a proper theatre entrance with columns) – a feature, she pointed out in her email, one does not encounter commonly in Canada.

Front entrance of the Centaur Theatre, housed in the former Montreal Stock Exchange.

The German photographer Andreas Gursky, who has captured various international stock exchanges from Chicago to Hong Kong, frequently employs the bird's-eye point of view. Measuring over six metres in height, his image *Chicago Board of Trade II* (1999), Brad Finger and Christiane Weidemann write, "shows futures traders cramming together like ants on the trading floor" (Finger and Weidemann 2011: 71). Charlotte Bonham-Carter and David Hodge point out similarly that in the Chicago image "the frantic energy on the floor is intensified by Gursky's digital tweaking of colours to an almost hallucinatory effect" (Bonham-Carter and Hodge 2013: 158). Gursky has stated: "Space is very important for me but in a more abstract way, I think [...]. I read a picture not for what's going on there, I read it more for what's going on in our world generally" (Gursky, cited in Finger and Weidemann 2011: 71). Photographing the Centaur in Montreal, I pursued the opposite objective, aiming to capture in detail the paradoxical transformation of a stock exchange into a theatre.

Montreal is Canada's most theatrical city. Mixing architectural styles from Europe and North America, it enjoys being on display. Numerous streetlights, illuminating this city, come in every shape and size. The old-fashioned ones in Old Montreal resemble the landmark cube-shaped lanterns decorating the Moscow Art Theatre.

LA Lights

The entrance of the Los Angeles County Museum of Art (LACMA) is decorated with a forest of streetlights, tall as palm trees. Collected by Chris Burden from various towns in Southern California, these lights date from the 1920s and 1930s. The largest one measures nine metres in height.

In his book *America*, Jean Baudrillard describes Los Angeles as a "pure open space, the kind you find in the desert" – "no verticality or underground" (Baudrillard 1988: 125). "Why is LA, why are the deserts so fascinating?" Baudrillard asks (Baudrillard 1988: 123–124). He answers that in place of "all depth," Los Angeles offers "a brilliant, mobile, superficial neutrality, a challenge to meaning and profundity" (Baudrillard 1988: 124). "This is why," he continues, "even the flight from London to Los Angeles, passing over the pole, is, in its stratospheric abstraction and its hyperreality, already part of California and the deserts" (Baudrillard 1988: 126).

My own flight from Edmonton to Los Angeles took about three hours. I looked forward to shedding my winter coat and enjoying California's sunshine. Walking from Marina del Rey to Venice Beach on my first day in LA, I photographed flowers and trees, which, in contrast to Edmonton's winter wonderland, were in full bloom. The palm trees, tall and slender, made the biggest impression on me. They stood out dramatically in LA's "pure open space." Another rare instance of verticality were those streetlights near LACMA – a theatrical challenge to the desert.

Arriving to the Earth, the seventh planet he visited, the protagonist of *The Little Prince* (1943) by Antoine de Saint-Exupéry observes:

> To give you an idea of the size of the Earth, I can tell you that before the invention of electricity it was necessary to maintain, over the whole of the six continents, a veritable army of four-hundred-and-sixty-two thousand five-hundred-and-eleven lamplighters.
>
> (Saint-Exupéry 1995: 56)

"Seen from not so high up," the Little Prince continues, "the effect was very splendid" (Saint-Exupéry 1995: 56). He points out that the lamplighters' movements were "regulated like a ballet in an opera" (Saint-Exupéry 1995: 56). New Zealand and Australia were first to light their lanterns and go to sleep; next "in the dance" were China and Siberia, who "entered on cue" (Saint-Exupéry 1995: 56). Then came Russia and the Indies, Africa and Europe, South Africa, and finally, North America. Everyone maintained "their order of appearance on stage," except for the North Pole lamplighter, who operated a single light and lived a life of "careless indolence" (Saint-Exupéry 1995: 56). The lamplighter from the South Pole also "went to work only twice a year" (Saint-Exupéry 1995: 56).

Las Vegas Mirage

In Las Vegas, where the neon burns brightly at all hours, shows are staged directly at hotels. I stayed at the landmark Mirage, offering unobstructed views of the Strip, the city's famous thoroughfare lined with replicas of various architectural wonders from around the world. My room faced the reproductions of palaces and canals of Venice. Beyond Venice were mountains, resembling theatrical props. Like other Las Vegas hotels, the Mirage has a casino and a theatre auditorium, both located on the ground floor. The casino takes up the lion's share of the hotel's posh lobby. In addition, the theatre has to compete with the man-made volcano that nightly spews tall columns of fire near the hotel's entrance.

Stanislavsky writes with indignation about his contemporary theatres: "Three quarters of the usual theatre is given over to the spectators, who have buffets, tea rooms, foyers, smoking rooms, dressing rooms, corridors for promenades" (Stanislavsky 1952: 297). The actors, conversely, occupy "tiny rooms under the stage" (Stanislavsky 1952: 297). At the Hermitage Theatre, with its dartboard in the lobby, Stanislavsky faced the formidable task of "turning the stable into a temple" (Stanislavsky 1952: 324). Following a stint at the Hermitage, the Moscow Art Theatre moved to its now iconic building on Kamergersky Lane, also requiring substantial renovation. Stanislavsky praised the architect Fedor Shekhtel, who decorated the lobby "with extraordinary simplicity," so as to save "all the color spots and effects for the stage" (Stanislavsky 1952: 388).

In Las Vegas, I saw *Love* by the famous Cirque de Soleil, performed at the Mirage. A tribute to The Beatles, this Wagnerian "total-work-of-art" production, combining elements of various arts, made every effort to surpass the hotel's other attractions. The show even brought to life the "octopus's garden," with acrobats performing wild stunts from the tentacles of a giant puppet octopus suspended high above the auditorium.

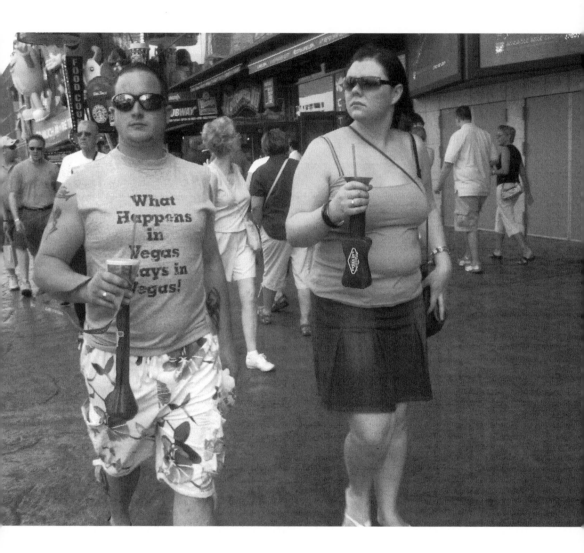

Like Eisenstein's "collision montage," the Strip observes no hierarchy. It mixes freely the pyramids and sphinxes of Egypt with the oversized cartoon characters from the M&M's ads. The "secret of the desert," Jean Baudrillard writes about Las Vegas in his book *America*, is its "spellbinding discontinuity, an all-enveloping, intermittent radiation" (Baudrillard 1988: 127).

South Bank Beyond Shakespeare

London's flamboyant South Bank offers such diverse attractions as Millennium Wheel, Shakespeare's Globe Theatre, and spontaneous outdoor performances. The Shakespeare's Globe, officially unveiled in 1997, remains open to the public at all times. This authentic reproduction of the sixteenth-century Globe is situated just over 200 metres from the original site. The new Globe performs shows from May to October, and in the remaining months it functions as a museum.

In Moscow, the School of Dramatic Art Theatre, constructed in 2004, incorporates its own Globe replica. Featuring several state-of-the-art auditoriums, this venue serves primarily as a theatrical laboratory and an acting school, and, in contrast to London, it offers only occasional public performances. This demonstrates that Stanislavsky's vision of the theatre as a temple continues to garner support in contemporary Russia.

Further down the South Bank, I photographed the National Theatre, its severe 1970s architecture contrasting sharply with the Shakespeare's Globe. The renowned playwright Bernard Shaw strenuously objected to the construction of the National. He argued, Marvin Carlson writes, that the "tawdry" South Bank of his time would "tarnish the establishment's image" (Carlson 1989: 94). Today, the National's concrete walls and sets of stairs are popular with graffiti artists, as well as skateboarders, whose perilous turns and twists attract crowds of spectators.

The neighbouring Tate Modern, with its signature smokestack, was originally constructed as a power station. Reopened in 2000 as an art gallery, the Tate has an impressive entrance with a grove of slender birch trees, which always makes me feel nostalgic for Russia.

The Shakespeare's Globe on a windy day in early winter. School girls in their uniform, navy trench-coats and smart hats, are rushing to the theatre's crowded entrance to attend an excursion.

Near the Millennium Wheel, also known as the London Eye, I photographed some impressive living statues. Compared to street performers, the motionless living statues lend themselves more easily to being photographed. In *Camera Lucida*, Roland Barthes writes that photography transforms "subject into object, and even, one might say, into a museum object" (Barthes 1994: 13). The photographer, Barthes adds, "knows this very well, and himself fears (if only for commercial reasons) this death in which his gesture will embalm [the subject]" (Barthes 1994: 14). In "Photography and Fetish," Christian Metz states similarly that photography "by virtue of its signifier (stillness, again) maintains the memory of the dead *as being dead*" (Metz 2003: 141). The film, Metz argues, "gives back to the dead a semblance of life" (Metz 2003: 141).

This intimate link between photography and death is the chief reason why I have refrained from taking pictures of theatre productions. Captured on film, a live show loses its essential characteristic – being live. Barbara Morgan, who photographed performances by Martha Graham and other celebrated dancers of the 1930s and early 1940s, was aware of this mutation. Morgan described herself as a "kinetic light-sculptor," and referred to her work as "my poems" (Morgan, cited in Patnaik 1999: 8).

More recently, the artists Gilbert and George, who exhibit their bodies as "living sculptures," have sought "to solve the age-old problem of the gap between art and life," Daniel Marzona writes in *Conceptual Art* (Marzona 2006: 58). In *Singing Sculptures* (1969), the two artists, "dressed in grey suits and with their faces and hands bronzed," sang "silently" to the tape-recording of a British hit from the 1930s (Marzona 2006: 58). According to Marzona, Gilbert and George perceive their entire artistic output – from performance to film to photography – as sculpture. They live in London's East End, and they call their house "Art for All."

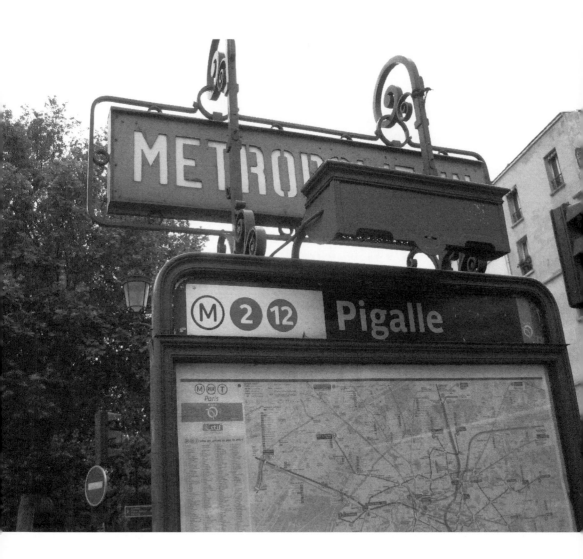

Overlooked Pigalle

The first time I visited this area, I photographed only the legendary cabaret Moulin Rouge and some of its immediate surroundings: a cobblestone street with an old-fashioned café, a stray dog sleeping peacefully by its front door. I later compiled a more inclusive set of images of Pigalle, capturing at length the Boulevard de Clichy with its X-rated cinema houses, sex shops, and the Musée de L'Erotisme.

In *On Photography*, Sontag discusses Michelangelo Antonioni's documentary *Chung Kuo* (1973), portraying the darker side of China. The Chinese authorities, Sontag writes, harshly criticized Antonioni for depicting old things and "indecorous moments" (Sontag 1982: 361). Antonioni was also reproached for using close-ups, fragmentary shots, and shots from behind. In contrast to 1970s China, which recognized "only two realities" – "a right one and a wrong one" – the West, Sontag argues, "proposes a spectrum of discontinuous choices and perspectives" (Sontag 1982: 363). The West, she continues, appreciates "the beauty of the cracked peeling door, the picturesqueness of disorder, the force of the odd angle and the significant detail, the poetry of the turned back" (Sontag 1982: 362).

This distinction between the restrictive China and the open-minded West might not be as clear-cut. Western tourist guides tend to picture pretty postcard views of Moulin Rouge, while providing no further images of Pigalle. During the production of Baz Lerhman's *Moulin Rouge!* (2001), "location shooting was eschewed," Zachary Ingle points out in *World Film Locations: Paris* (Ingle 2011: 82). The film's digital recreations and life-sized sets, Ingle explains, aimed to emphasize the "artificiality" of the classical Hollywood musical and that of the *Belle Epoch* (Ingle 2011: 82).

In "A Short History of Photography," Walter Benjamin singles out Eugene Atget, whose images of Paris focus on "what was unremarked," rather than the "so-called landmarks" (Benjamin 2006: 61). Among other things, Atget portrays restaurant tables "after people have finished eating and left," or "the brothel at Rue ... no. 5, whose number appears, gigantic, at four different places on the building's façade" (Benjamin 2006: 62). In most of Atget's pictures, Benjamin adds, the city "looks cleared out" (Benjamin 2006: 62). However, he argues, Atget's empty streets and street corners "are not lonely, merely without mood" (Benjamin 2006: 62).

The Hungarian-born photographer Brassai has also captured the darker side of Paris. In contrast to Atget, his book of photographs *Paris by Night* (1933), Mary Warner Marien writes in *Photography: A Critical History*, "teems with people who exist at the twilight of respectable society" (Warner Marien 2006: 257). Discussing his "'Bijou' (Jewel) of Montmartre" (1933), Warner Marien points out that Brassai placed "viewer and subject in an uncomfortably confrontational relationship that exploited the photograph's psychological power" (Warner Marien 2006: 257).

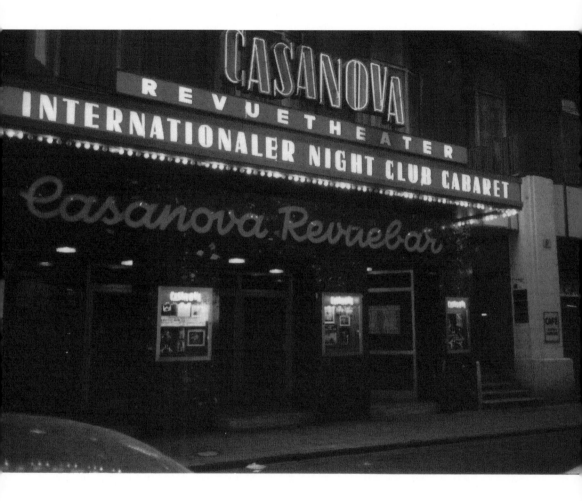

Vienna Noir

I photographed the Casanova nightclub in passing, well before discovering Carol Reed's noir classic *The Third Man* (1949). At the time, I had just watched a remarkable show based on Casanova's memoirs, performed on a temporary candle-lit stage in Moscow. The city of Mozart and ballroom dancing, Vienna also has a darker side. The characters of Reed's film "are purposeful in this city but hunted," Rob White writes in his BFI volume on *The Third Man* (White 2003: 46). At Casanova, "a scantily-clad dancer is gyrating to bland jazz played by muted horns" (White 2003: 49). Holly Martins "is getting drunk"; he buys a large bouquet from the club's flower-seller, and "at the end of a long day, heads over to Anna's" (White 2003: 49).

The Third Man opens with a mock-documentary sequence, depicting grim racketeers, a dead body floating "among hunks of cracked ice in grimly-looking water," and Vienna's classical façades and statues "reduced to rubble" (White 2003: 7). White argues: "The damage done in war is evident in the sequence even though Reed's voiceover and fast cutting (twenty-eight different shots in sixty-six seconds) discourage the viewer from dwelling on it" (White 2003: 8).

In contrast to Reed, the Soviet photographer Evgeny Khaldei wants the viewer to acknowledge the devastation of the occupied Vienna. "That's the bridge over the Danube, the blue Danube … or rather what's left of it," reads the caption of one of Khaldei's images (Khaldei 1999: 148). According to Khaldei, his famous 1945 image of Soviet soldiers raising the flag of victory over the Reichstag "was processed and published immediately" (Khaldei 1999: 151). Conversely, his disturbing photographs of occupied Vienna remained in Khaldei's family archives for many decades, and were exhibited for the first time only in the 1990s – some 50 years after Khaldei had taken them.

"There's a concert hall in Vienna/ Where your mouth had a thousand reviews," reads a line from Leonard Cohen's 1979 poem "Take This Waltz" (Cohen 1993: 353). Subtitled "After Lorca," this poem is a loose translation of Federico Garcia Lorca's "Little Viennese Waltz" (1930). In Cohen, as in Lorca, pre-war Vienna is a city of both the waltz and death. It is a place where "death comes to cry," and where the waltz itself, with its "broken waist" and "a clamp on its jaws," has been "dying for years" (Cohen 1993: 353). Like Reed's film *The Third Man*, the poem exhibits a strong contrast between its more cheerful pace (in this instance, the waltz tempo) and dark imagery. But unlike the film's sober, often ironic narrative, the poem's overall mood remains one of sadness and melancholy. In Cohen and Lorca, death is still romantic; in Reed's film, depicting the immediate aftermath of World War II, death is a fact of life, an everyday occurrence.

Blue Door Havana

It is a rainy morning in Havana. My fellow tourists dissipate, each in search of their own treasure. The setting is the complete opposite of our pristine seaside resort in Varadero. An old cathedral is under reconstruction with scaffolding and various construction equipment. I photograph a pretty square just outside the cathedral, capturing the wet trees and the wet pavement. Three old men in straw hats are playing folk songs. The building next to them has a set of tall bright-blue doors.

In *On Photography*, Sontag writes about "the beauty of the cracked peeling door" and how it appeals to the Western viewer, who appreciates "the picturesqueness of disorder" (Sontag 1982: 362). Sontag contrasts this sensibility with that of Communist China, where photography was required to embellish reality. I take no side in this divide, or rather, as a native Russian, I can relate to both. The blue doors in Havana attracted me for a different reason. Like a chair, a doorway can serve as an improvised stage.

Cuba, it appears, follows its own path, entirely different from either China or Russia. Capturing the revolution in Cuba, Alberto Korda employed "the same ideas and techniques as in fashion photography," Jaime Sarusky writes in his introduction to Korda's book of photographs (Sarusky 1996: 12). Korda's hero was the photographer Raul Corrales, who as a teenager devoured foreign magazines, "whose photos made his imagination soar" (Sarusky 1996: 5). At the Havana airport, waiting for my flight back to Canada, I leaf through pictures by Korda and Corrales, in which Cuba's capital looks like a glamorous movie set: tropical nature, the sea, and handsome rebels in black berets marching on the old regime. In 1930s Moscow, the revolutionary director Vsevolod Meyerhold hoped to construct a new theatre with a stage shaped like a catwalk. He was not able to realize his dream – palm trees do not grow in Russia.

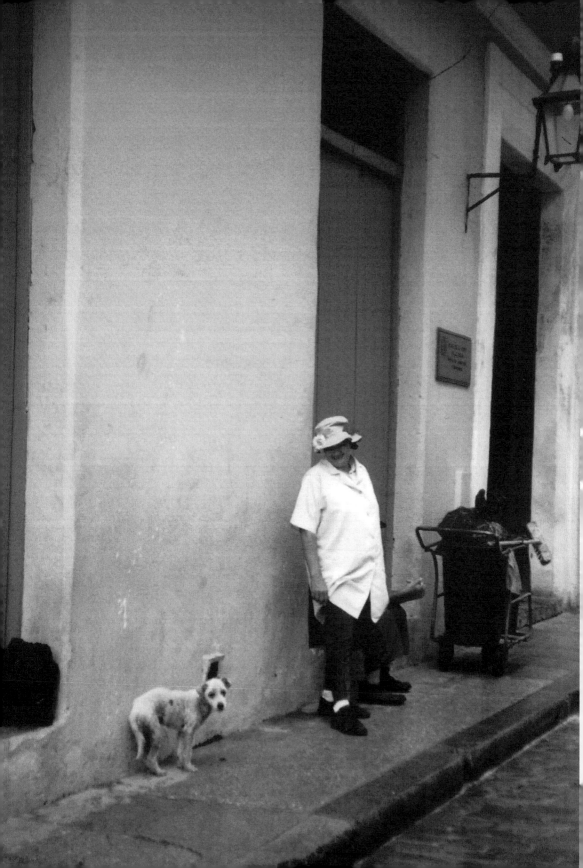

In his essay "Shock-Photos" (1988), Roland Barthes differentiates between the "overconstructed" and "literal" representation of disturbing events – an important distinction that sheds light on images of Cuba's revolution by Korda and Corrales, inspired by glossy fashion magazines from the West. Discussing the "Shock-Photos" exhibit at the Galerie d'Orsay in Paris, Barthes writes that most of the exhibited pictures failed to produce the desired effect. The photographer, he explains, "almost always *overconstructed* the horror he is proposing, adding to the *fact*, by contrasts and parallels, the intentional *language* of horror" (Barthes 1988: 71). He cites several examples of this, including a shot that depicts "a column of prisoners passing a flock of sheep" (Barthes 1988: 71). Barthes juxtaposes these "all too skilful" images to a selection of news-agency photos, also displayed at the exhibit. The "naturalness" of the latter group of images, he argues, "compels the spectator to a violent interrogation" (Barthes 1988: 93). According to Barthes, the "visibly diminished" news-agency photographs exhibit "that catharsis Brecht demands," rather than "an emotive purgation," characteristic of painting.

Fringe Edmonton

The Old Strathcona area in Edmonton, where the annual Fringe Theatre Festival takes place, is populated mostly by industrial structures, such as the Transalta Arts Barns, an old bus barn repurposed as a theatrical venue. The unusual Orange Hall, a one-story wood structure with a pointed roof, was originally constructed in 1903 as a gathering space for the members of the Loyal Orange Lodge. During the Fringe, this entire area transforms into a chaotic playground, offering both indoor and outdoor shows, numerous food outlets, and a fairground with an old-fashioned Ferris wheel. I also photographed improvised advertising kiosks, rows of white tents, and ubiquitous large green trash bins.

This anarchic setting – a cross between a traveling circus and a refugee camp – seemed strangely appropriate for the dramatization of Picasso's famous painting *Guernica* (1937) that depicts the destruction of the small town of Guernica during the Spanish civil war. The production of *Guernica* (2011) was staged in the makeshift auditorium of a dilapidated warehouse. My theatre pass cryptically identified it as "BYOV 26: Phabrik Art and Design" (BYOV, I later learned, stands for "Bring Your Own Venue").

I was reminded of watching Marina Tsvetaeva's play *Adventure* (1919), performed on a similarly makeshift stage in the Russian Theatre Academy in Moscow. In Ivan Popovski's production of *Adventure,* first staged in 1991, this was a deliberate choice intended to emphasize Tsvetaeva's conflicted attitude to theatre. She describes theatre as a "violation of my solitude with the Hero" (Tsvetaeva, cited in Anokhina 2000). In Edmonton, the choice of the venue was simply a matter of course. But staging the show in that ramshackle BYOV 26 was also a lucky strike. Picasso states: "I have often used pieces of newspaper in my collages, but not to produce a newspaper" (Picasso, cited in Walther 2007: 40).

Counting to Ten with Nabokov

The last chapter of Nabokov's *Invitation to a Beheading* (1936) describes the execution of the novel's protagonist Cincinnatus. The only opaque individual in Nabokov's unnamed country populated by transparent beings, Cincinnatus is sentenced to a beheading. Nabokov describes in detail the preparation for the beheading, the arrival of the pompous executioner, and the crowd of transparent spectators. Speaking in a loud voice, the "deputy city director" announces several upcoming events, including a furniture exhibit and the performance of the "new comic opera *Socrates Must Decrease*" (Nabokov 1989: 220). The deputy director then turns to the execution: "Now I make way for other performers and hope, townspeople, that you are all in good health and lack nothing" (Nabokov 1989: 221).

Cincinnatus is asked to count to ten. He notices that beyond the first rows of spectators, "there followed other rows where eyes and mouths were not clearly drawn" (Nabokov 1989: 220). The furthest rows "were really quite badly daubed on the backdrop" (Nabokov 1989: 220). There was also "something wrong with the sun, and the section of the sky was falling" (Nabokov 1989: 219). Poplar trees, "stiff and rickety," were falling down as well (Nabokov 1989: 219).

Soon the entire set disintegrates: the execution platform collapses "in a cloud of reddish dust," and the two-dimensional trees "lay flat and reliefless" (Nabokov 1989: 223). "Amidst the dust, and the falling things, and the flapping scenery," Cincinnatus departs the scene, heading in a "direction where, to judge by the voices, stood beings akin to him" (Nabokov 1989: 223). Seamlessly merging life and art, Nabokov's novel brings attention to, among other things, the ephemeral nature of theatre – a medium that, unlike cinema and literature, leaves behind no material record.

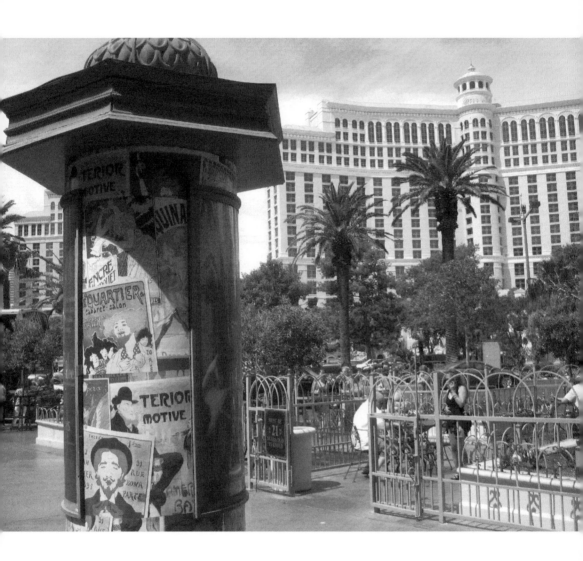

Permanent advertising kiosks, found everywhere from Moscow to Las Vegas, attempt to combat the theatre's short lifespan. More true to the ephemeral medium of theatre is a temporary kiosk from Edmonton's Fringe Festival in the opposite picture.

185

Broadway Backstage

Broadway, March 2012. Times Square somehow appears less overwhelming. It is a weekday, and there is a thinner crowd, mostly locals. I take a few snapshots, focusing on things I have overlooked in the past – smaller venues, such as the understated Jerry Orbach Theatre. Next to it, a grocery store window displays rows of cans and bottles in the style of Andy Warhol. An ad in the window's top corner reads: "How I Feel."

Near the Winter Garden Theatre playing the ubiquitous *Mama Mia!* musical, I spot another wild compilation of names and ads – shoes, sushi, and a clothing store nostalgically called "Backstage Memories". I think back to 2006, when I came to Broadway in search of the New Amsterdam theatre, the setting of the Chekhov-inspired film *Vanya on 42nd Street* (1994). Since then, I have collected hundreds and hundreds of pictures. I store the analogue ones in cardboard boxes, next to some more boxes containing my photographs of Moscow, most of them reproduced in the first book of *Theatre in Passing*.

"I really hate nostalgia," Warhol writes in his witty *The Philosophy of Andy Warhol* (Warhol 1975: 145). Warhol admired the "Japanese way of rolling everything up and locking it away in cupboards" (Warhol 1975: 144). The cupboard, he insists, should be kept elsewhere: "If you live in New York, your closet should be, at the very least, in New Jersey" (Warhol 1975: 144). Warhol himself "started off with a trunk," replacing it later with cardboard boxes, which he secretly hoped would "get lost" (Warhol 1975: 145). He adds: "But my other outlook is that I really do want to save things so they can be used again someday" (Warhol 1975: 145).

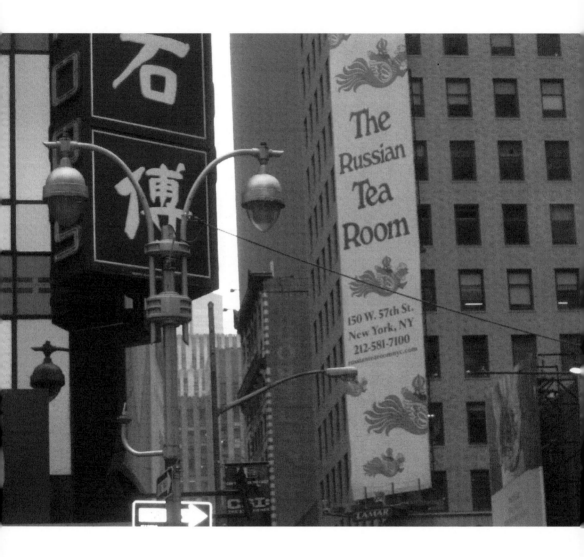

Like Warhol, I feel conflicted about my cardboard boxes, containing photographs of performance spaces and other theatrical memorabilia. Wanting to pay some due to this collection, I organized the *Consumed* exhibit at the University of Alberta, where I teach. The show included participation of the staff and students from the Faculty of Arts, who interpreted the central theme each in their own way. My colleague Anne Malena, who teaches French and translation, contributed a pie, "baked" with the binders of old books from her personal library. Andriko Lozowy, a graduate student from the Department of Sociology and my co-curator, displayed a vertical row of black-and-white photographs of West Edmonton Mall – the quintessential consumer paradise. My own contribution included a framed image of a Moscow trash bin, as well as a corkboard displaying an old theatre programme, some used theatre passes, and an empty pack of *Benson & Hedges.*

My corkboard assemblage was inspired by a short entry on Justin Gignac's NYC Garbage project, published in *The Globe and Mail* newspaper in August 2011. According to *The Globe*, Gignac "started small, encasing bits of refuse found on the street in clear acrylic boxes and selling them as collectibles for a modest $10 in 2001" (Wrobel 2011: 14). Since then, he has sold "more than 13,000 cubes to people in more than 30 countries," and he now offers "$100 limited-edition cubes," containing garbage gathered at special events, such as President Barack Obama's inauguration (Wrobel 2011: 14). Following the closure of the *Consumed* exhibit, I relocated my theatre-refuse corkboard to my university office, where it still languishes amidst piles of papers and books. On my trip to New York a few months later, I collected more photographs, maps, and theatre memorabilia. Warhol laments in his book: "I breach what I preach more than I practice it" (Warhol 1975: 144).

Christmas in London

I celebrated Christmas of 2012 in London – a short break from this project with the hope of finishing it upon my return. Walking along the Strand on Christmas day, I discover a cluster of ads for *Uncle Vanya*, displayed on the Vaudeville Theatre. Chekhov, who authored a number of vaudevilles, insisted, time and again, that his full-length plays must not be staged as tragedies. He identified *The Cherry Orchard* as a "Comedy in 4 Acts" – a subtitle which perplexed both Stanislavsky and Nemirovich-Danchenko. The two co-founders of the Moscow Art Theatre found little humour in the story about the demise of the beautiful cherry orchard, sold at an auction to cover its owner's debt. Commenting on his performance as Astrov in *Uncle Vanya*, Chekhov mystified Stanislavsky yet again: "He whistles. Listen, he whistles! Uncle Vanya is crying, but Astrov whistles!" (Stanislavsky 1952: 366). "'How is that?' I said to myself," Stanislavsky writes, "Sadness, hopelessness, and merry whistling?" (Stanislavsky 1952: 366).

In London, I took many pictures of the old-fashioned Vaudeville with its *Uncle Vanya* ads. Judging from the ads, it is a costume drama, attempting to recreate authentically Chekhov's Russia. "Tragic But Also Funny," reads one of the bright-red playbills at the entrance. Later that afternoon, I photographed the festive *Mama Mia!* billboards on the Novello Theatre, resembling those that I had encountered in New York. The Drury Lane Theatre, also located within walking distance from the Vaudeville, displays the neon-green ads for *Shrek the Musical*. This wild montage of billboards may be contradictory, but it makes perfect sense. In Chekhov's plays, everyone is also absorbed by their own thoughts, paying little attention to what the others are saying. And yet, those individual solitudes somehow manage to form a fragile community.

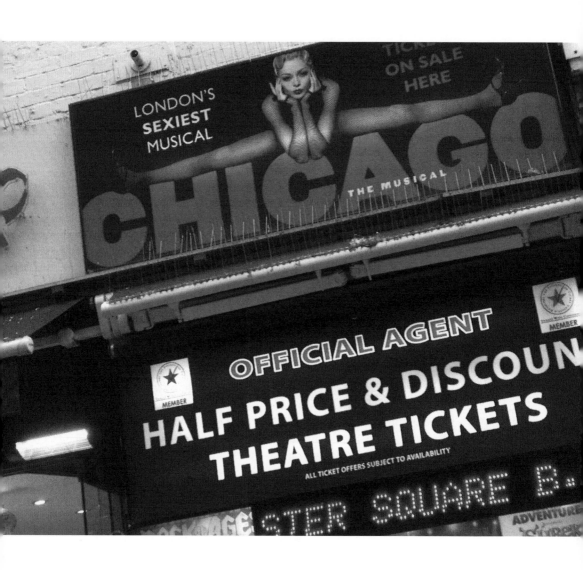

The concluding scene of *Uncle Vanya* provides no resolution. Professor Serebryakov and his beautiful wife Yelena have just departed, once again leaving Vanya in charge of their country estate. Astrov is also about to leave. "And so you're on your way without tea," complains the old nanny Marina, restating her concern from Act One (Chekhov 1977: 94). Delaying his exit, Astrov inspects a map of Africa on the wall: "Ah, way down there is Africa, I'll bet there's a blazing heat wave now – a terrible scorcher!" (Chekhov 1977: 95). Ignoring Astrov, Vanya continues writing in his account book: "February second, oil, twenty pounds …" (Chekhov 1977: 95). It is time for me to say my goodbyes as well. Goodbye London and the Strand. Goodbye Strand Palace hotel, my home away from home for many years. I discovered it, with Katy's help, on my first visit to London, choosing it over cosier accommodations on and around Oxford Street. I now stay more frequently in Fitzrovia, located on a more direct route to Paddington Station, with its fast train to Heathrow Airport. At Heathrow two days later, barren trees still display Christmas lights. I look forward to celebrating the New Year, wherever it might catch me – Montreal, Moscow, or even Africa, where "I'll bet there's a blazing heat wave now."

Acknowledgements

Thank you friends in different countries: many of you are in this book. Thank you Dennis Kilfoy for your thoughtful proofreading. Thank you Intellect Books for your vision and your inspiring list of titles. Thank you Valeri, my restless father, to whom I owe the gift of itchy feet. Thank you Eddie for sharing the road, red-eye flights, hurried meals at Starbucks, and that insane sunrise in Lagos. And Rita, this one is also for you – все еще впереди.

Earlier versions of some parts of this book have appeared in print: "High-Rise Zhivago" (2014), *Imaginations: Journal of Cross-Cultural Image Studies/Revue d'Études Interculturelles de l'Image*, 5:1, http://www3.csj.ualberta.ca/imaginations/?p=5205; "Death in Vienna" (forthcoming 2014), *Space and Culture: International Journal of Social Spaces*, 17:3; "Blue Door Havana" (2013), *Imaginations: Journal of Cross-Cultural Image Studies/Revue d'Études Interculturelles de l'Image*, 4:1, http://www3.csj.ualberta.ca/imaginations/?p=4384; "In Search of True America: Images from Ilf and Petrov's 1935 American Road Trip" (2010), *Proceedings of the 11th Conference of the International Society for the Study of European Ideas (ISSEI)*, University of Helsinki, Finland, 28 July–2 August 2008, Helsinki: University of Helsinki, http://hdl.handle.net/10138/15325; "Back to Versailles: On the Restoration of Country Estates in Post-Soviet Russia" (2007), in ed. J. Douglas Clayton, *La Russie et le monde francophone*, Ottawa: Le Group de recherché en études slaves de l'Université d'Ottawa, pp. 291–304. I would like to acknowledge the Faculty of Arts, University of Alberta, for the publication subvention grant.

Images: All photographs are by Elena Siemens.

Works Cited

Adriani, Gorz, ed. (2001), *Keith Haring – Heaven and Hell*, Ostfildern-Ruit: Hatje Cantz Publishers.

Alden, Todd (1999), *The Essential René Magritte*, New York: The Wonderland Press.

Anokhina, Natalia (2000), "Ne prosto liubov', a Liubov'," in *Narodnaia Gazeta*, http://theatre.Fomenko.narod.ru/notices_adventure_08.html, accessed 24 December 2000.

Barthes, Roland (1981), *Camera Lucida* (trans. Richard Howard), New York: Hill & Wang.

Barthes, Roland (1982), *Empire of Signs* (trans. Richard Howard), New York: Hill & Wang.

Barthes, Roland (1985), "The Greek Theater," in *The Responsibility of Forms: Critical Essays on Music, Art, and Representation* (trans. Richard Howard), New York: Hill & Wang, pp. 63–88.

Barthes, Roland (1988), "Shock-Photos," in *The Eiffel Tower and Other Mythologies* (trans. Richard Howard), New York: Farrar, Straus and Giroux, pp. 71–73.

Baudrillard, Jean (1988), *America* (trans. Chris Turner), London: Verso.

Benjamin, Walter (1986), "Moscow," in *Reflections: Essays, Aphorisms, Autobiographical Writings* (trans. Edmund Jephcott), New York: Schocken Books, pp. 97–130.

Benjamin, Walter (2006), "A Short History of Photography," in ed. Charles Merewether, *The Archive: Documents of Contemporary Art*, London: Whitechapel, pp. 58–64.

Bonham-Carter, Charlotte and Hodge, David (2013), *Contemporary Art: The Essential Guide to 200 Groundbreaking Artists*, third edition, London: Goodman.

Brodsky, Joseph (1987), "Flight from Byzantium," in his *Less Than One: Selected Essays*, New York: Farrar, Straus and Giroux, pp. 393–446.

Campany, David (2007), *Art and Photography*, London: Phaidon Press.

Carlson, Marvin (1989), *Places of Performance: The Semiotics of Theatre Architecture*, Ithaca: Cornell University Press.

Carrol, Lewis (1992), "Alice's Adventures in Wonderland," in eds. John W. Griffith and Charles H. Frey, *Classics of Children's Literature*, New York: Macmillan Publishing, pp. 427–482.

Chekhov, Anton (1977), *The Cherry Orchard*, in trans. and ed. Eugene K. Bristow, Anton Chekhov's Plays, New York: W. W. Norton & Company, pp. 159–211.

Chekhov, Anton (1977), *The Seagull*, in trans. and ed. Eugene K. Bristow, *Anton Chekhov's Plays*, New York: W. W. Norton & Company, pp. 1–52.

Chekhov, Anton (1977), *Uncle Vanya*, in trans. and ed. Eugene K. Bristow, *Anton Chekhov's Plays*, New York: W. W. Norton & Company, pp. 53–96.

Cohen, Leonard (1993), "Take This Waltz," in *Stranger Music: Selected Poems and Songs*, New York: Pantheon Books, p. 353.

Coupland, Douglas (2009), *City of Glass: Douglas Coupland's Vancouver*, Revised Edition, Vancouver: Douglas & McIntyre.

De Certeau, Michel (1988), *The Practice of Everyday Life* (trans. Steven Rendall), Berkeley: University of California Press.

Defraeye, Piet and Devos, Mike (2012), unpublished translation of Bart Moeyaert's "Klein."

De Saint-Exupery, Antoine (1995), *The Little Prince* (trans. V. F. Cuffe), London: Penguin Books.

Eisenstein, Sergei (1969), *The Film Sense*, (trans. and ed. Jay Leyda), San Diego: A Harvest Book, pp. 3–68.

Eisenstein, Sergei (1988), "The Montage of Attractions," in trans. and ed. Richard Taylor, *The Film Factory: Russian and Soviet Cinema in Documents 1896–1939*, London: Routledge, pp. 87–89.

Eisenstein, Sergei (1995), "The Twelve Apostles," in ed. Richard Taylor, trans. William Powell, *Beyond the Stars: The Memoirs of Sergei Eisenstein*, London: BFI Publishing, pp. 153–180.

Eisenstein, Sergei (1995), "A Miracle in the Bolshoi Theatre," in ed. Richard Taylor, trans. William Powell, *Beyond the Stars: The Memoirs of Sergei Eisenstein*, London: BFI Publishing, pp. 181–183.

Eisenstein, Sergei (1995), "My Encounter with Mexico," in ed. Richard Taylor, trans. William Powell, *Beyond the Stars: The Memoirs of Sergei Eisenstein*, London: BFI Publishing, pp. 411–423.

Eisenstein, Sergei (1977), *Film Form: Essays in Film Theory*, (trans. and ed. Jay Leyda), San Diego: A Harvest Book.

Everett-Green, Robert (2013), "Sebastiao Salgado/ Edward Burtynsky," *The Globe and Mail*, 4 May, pp. 9–11.

Finger, Brad and Weidemann, Christiane (2011), *50 Contemporary Artists You Should Know*, Munich: Prestel.

Foreman, Richard (2007), "Excerpts Concerning Ice Theatre," in eds. Hester Aardse and Astrid van Baalen, *Findings on Ice*, Amsterdam: Pars Foundation, pp. 130–135.

Golden, Reuel (2013), *Masters of Photography*, third edition, London: Goodman.

Ilf, Ilya and Petrov, Evgeny (2007), ed. Erika Wolf, trans. Annie O. Fisher, *Ilf and Petrov's American Road Trip*, New York: Cabinet Books.

Ingle, Zachary (2011), "Moulin Rouge!" in ed. Marcelline Block, *World Film Locations: Paris*, Bristol: Intellect Books, p. 82.

Kabbery, Rachel and Brown, Amy K. (2001), *The Mini Rough Guide to Paris*, London: Rough Guides.

Khaldei, Evgeny (1999), "Interview," in *Von Moskau Nach Berlin: Jevgeni Khaldei*, Berlin: Parthas, pp. 134–150.

Kiaer, Christina (2008), "Looking at Tatlin's Stove," in eds. Valerie A. Kivelson and Joan Neuberger, *Picturing Russia: Explorations in Visual Culture*, New Haven: Yale University Press, pp. 148–151.

Kuhl, Isabel (2008), *Andy Warhol*, Munich: Prestel.

Kushner, Tony (2012), "Splendor in the Park," *Vanity Fair*, July, p. 101.

Lederman, Marsha (2012), "Vancouver Gets the Last Laugh," *The Globe and Mail*, 24 July, p. 3.

Marker, Chris (2007), "La Jetée," in ed. David Campany, *The Cinematic*, London: Whitechapel, pp. 175–176.

Marzona, Daniel (2006), *Conceptual Art*, ed. Uta Grosenick, Koln: Taschen.

Mersal, Iman (2007), "Memory of Thalg," in eds. Hester Aardse and Astrid van Baalen, *Findings on Ice*, Amsterdam: Pars Foundation, pp. 146–150.

Metz, Christian (2003), "Photograph and Fetish," in ed. Liz Wells, *The Photography Reader*, London: Routledge, pp. 138–145.

Nabokov, Vladimir (1989), *Invitation to a Beheading* (trans. Dmitri Nabokov in collaboration with the author), New York: Vintage Books.

Obraztsov, Sergei (1981), *Moia professiia (My Profession)*, Moscow: Iskusstvo.

Parr, Martin (2010), *Parr by Parr: Quentin Bajac Meets Martin Parr: Discussion with a Promiscuous Photographer*, Amsterdam: Schilt Publishing.

Parshin, Sergei (1993), *Mir Iskusstva (The World of Art)*, Moscow: Izobrazitelnoe Iskusstvo.

Patnaik, Deba P. (1999), "Barbara Morgan," in *Barbara Morgan: Aperture Masters of Photography Series*, Aperture Foundation, pp. 5–10.

Phillips, Sandra S. (2013), *Martin Parr*, London: Phaidon Press Limited.

Porter, Darwin and Prince, Danforth (2004), *Frommer's Portable Berlin*, Hoboken: Wiley Publishing.

Prigov, Dmitri (1997), "Raschety s zhizniu" ("Accounts with Life"), in ed. Victor Erofeev, *Russkie Tsvety Zla*, Moskva: Podkova.

Richardson, Dan (2001), *The Rough Guide to Moscow*, London: Rough Guides.

Rodchenko, Alexander (1991), "Against the Synthetic Portrait, For the Snapshot," in ed. John E. Bowlt, *Russian Art of the Avant-Garde: Theory and Criticism 1902-1934*, New York: Thames and Hudson, pp. 250–254.

Rodchenko, Alexander (2005), "The Paths of Contemporary Photography," in ed. Alexander N. Lavrentiev, *Aleksandr Rodchenko: Experiments for the Future: Diaries, Essays, Letters, and Other Writings*, New York: The Museum of Modern Art, pp. 207–212.

Rodchenko, Alexander (2007), "Ilya Ilf's American Photographs," in ed. Erika Wolf, trans. Annie O. Fisher, *Ilf and Petrov's American Road Trip*, New York: Cabinet Books, pp. 149–152.

Sarusky, Jamie (1996), "Raul Corales," in ed. Carlos Torres Cairo, *Raul Corales: La Imagen Y La Historia*, Florence: Aediciones Aurelia, pp. 4–5.

Sarusky, Jamie (1996), "Korda," in ed. Carlos Torres Cairo, *Alberto Korda: Diario de una Revolucion*, Florence: Aediciones Aurelia, pp. 11–13.

Senechal, Marjorie (2007), "Reflections on Ice," in eds. Hester Aardse and Astrid van Baalen, *Findings on Ice*, Amsterdam: Pars Foundation, pp. 114–117.

Slonim, Mark (1962), *Russian Theater: From the Empire to the Soviets*, New York: Collier Books.

Sontag, Susan (2003), *Regarding the Pain of Others*, New York: Farrar, Straus and Giroux.

Sontag, Susan (1990), *On Photography*, New York: Anchor Books Doubleday.

Stanislavsky, Konstantin (1952), *My Life in Art* (trans. J. J. Robbins), New York: Theatre Arts Books.

Sutton, Isabelle (2012), unpublished translation of Serge Gainsbourg's "La Valse de Melody."

Taylor, Kate (2012), "Now Playing: The Handyman Special," *The Globe and Mail*, 21 August, R1-2.

Tsvetaeva, Marina (1985), letter to Rilke from 14 August 1926, in eds. Yevgeny Pasternak, Yelena Pasternak, and Konstantin M. Azadovsky, *Letters Summer 1926: Boris Pasternak, Marina Tsvetaeva, Rainer Maria Rilke*, San Diego: Harcourt Brace Jovanovich Publishers.

Tolstoy, Leo (1968), *War and Peace* (trans. Ann Dunnigan), New York: The New American Library.

"Vancouver: Fairmont Pacific Rim," *enRoute* 8: 2011, p. 24.

Warhol, Andy (1975), *The Philosophy of Andy Warhol (From A to B and Back Again)*, San Diego: A Harvest/HBJ Book.

Warner Marien, Mary (2006), *Photography: A Cultural History*, second edition, London: Laurence King Publishing.

Wenders, Wim (2010), *Once: Pictures and Stories* (trans. Marion Kagerer), New York: DAP.

White, Rob (2003), *The Third Man: BFI Film Classics*, London: BFI Publishing.

Whybrow, Nicolas (2011), *Art and the City*, London: I. B. Tauris.

Wrobel, Maggie (2011), "Trash Talk," *The Globe and Mail*, 6 August, p. 14.